DOGS & PUPPIES

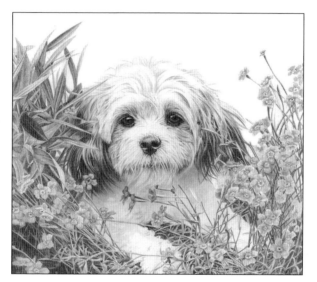

By Nolon Stacey

www.walterfoster.com

CONTENTS

INTRODUCTION

Possibly the simplest, cheapest, and most fundamental instrument at an artist's disposal is the pencil. Merely a piece of graphite used to make markings on paper, the pencil provides the cornerstone of any artist's creativity. The size of the pencil makes it extremely portable; together with a small pad of paper, it is the perfect tool for sketching while on the move. Because of its versatility, it can serve to roughly outline a painting or to create fantastic and intricate artwork in its own right.

Over the years, I have tried a number of media, including paint, pastel, and crayon, but nothing has rewarded me with the instant results that are attainable with pencil. The fact that I can pick up the pencil and immediately begin transferring my ideas to paper holds great appeal for me, as does the challenge of representing a three-dimensional, colorful world using a flat sheet of paper and a tool that produces only a range of grays! In this book, I will share what I have learned through years of trial and error. I also will demonstrate the basic techniques that I have found work best for me to compose and render the special characteristics specific to canines, as well as 10 step-by-step dog and puppy portrait lessons that will help you begin creating your own lifelike artwork.

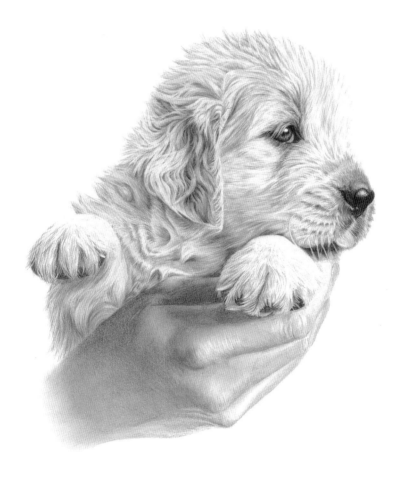

TOOLS AND MATERIALS

The pencil is the most basic of all art media; you can get started with only a pencil and a piece of paper. I will recommend a few additional tools that I like to use, but over time every artist discovers the set of tools that works best for him or her. Experimentation is the key!

Pencils

Artist's pencils are graded on a scale from soft (labeled "B" for "black") to medium (labeled "F" for "fine") to hard (labeled "H"). Softer leads create darker tones that are great for shading and blending; they also are much easier to manipulate with an eraser. Hard leads can produce light, fine lines, but avoid applying too much pressure as you stroke, as they easily can scar the paper's surface. There are 20 different grades of pencils, ranging from 9H to 9B. I don't believe it's necessary to buy all 20 grades; five or six spanning the range will suffice. I generally keep the following pencils on hand: 5B, 2B, HB, 2H, and 5H. As you purchase your set, just remember that the higher the number, the more exaggerated the quality (e.g., 9B is the softest available).

The most common pencil is the HB, which corresponds to the #2 pencil used in offices and schools. However, if I had to choose a single pencil to work with, I would opt for the 2B; this grade allows you to produce both very light tones and textures as well as near-black values, depending on the amount of pressure you apply.

In addition to grades of leads, there are many different types of pencils available. The most popular is the wooden pencil, which comprises a lead encased in a wooden sheath. The user can sharpen the pencil to a fine point for delicate lines or dull the point for broad lines or shading. I prefer a mechanical pencil (sometimes called a "clutch pencil"), which never needs sharpening. In contrast to wooden pencils, mechanical pencils do not change in weight or length, so you never need to adjust your feel for it. I use two types of mechanical pencils: one that holds a thin .2mm lead for a very fine point, and one that holds fatter .7mm lead for thick lines and fuller shading.

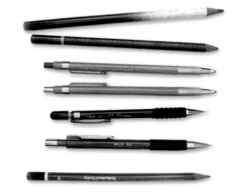

Types of Pencils You'll find that the material, shape, length, and weight of the barrel all affect your grip of the pencil. Test each type to see which feels most natural to you.

Paper

There are three main surfaces you can use for drawing: cold press paper, which has *tooth* or a slightly raised texture; hot press paper, which has a very smooth surface; and Bristol board (my preference), which is a fine-quality, heavyweight, smooth surface. The smoother the surface, the better suited for detail, as the tooth of rougher surfaces catches the graphite and makes it difficult to create smooth lines. Whatever type of surface you choose, use only archival, acid-free material that won't yellow or discolor over time.

Erasers

Erasers are invaluable art tools; in addition to removing mistakes, they can be used as drawing tools. There is a variety of eraser types available, and each has its own advantages. For example, you can create a highlight in hair by using the sharp edge of a hard vinyl eraser to lift out graphite. A pen eraser is similar to a large mechanical pencil but has an eraser core; to create a fine point for intricate erasing, simply use a conventional pencil sharpener. A kneaded eraser can be shaped into a fine point for detailed erasing, or flattened to gently lighten an area of graphite. And my preferred eraser, tack adhesive, is a reusable putty that is moldable like the kneaded eraser but more effective at lifting graphite.

Blending Tools

Use blending tools to smudge graphite, eliminate visible pencil strokes, merge dark tones into light, or smooth out textures. My favorite blending tools are tissues, paper towels, tortillons, and blending stumps. *Tortillons* and blending stumps are tightly wound sticks of paper. A tortillon is sharpened like a pencil at one end, whereas a blending stump is sharpened at both ends and is more tightly wound, producing a slightly different texture when rubbed on graphite. Chamois cloth also works well for achieving smooth blends. You should never blend with your finger; the skin leaves oils on the drawing paper, which can damage the surface or cause your shading to have an irregular tone.

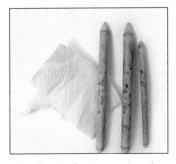

Choosing Tools Paper towels work well for large areas, but the range of blending stump and tortillon sizes allows you to work in large or small areas.

Additional Tools

There are a few more items you'll want to gather before you draw. I often keep a soft brush on hand for sweeping away bits of eraser or graphite from the paper, eliminating the temptation to use my hand. Contrary to what I was taught in art class, I use a ruler or straightedge when I need a perfectly straight line. Sometimes I even use a circle template for drawing pupils and irises when the subject is looking straight at the viewer. For indenting (a technique shown on page 13), I keep a knitting needle or empty mechanical pencil nearby. I also find a drawing compass useful for measuring and transferring proportions from a reference to my drawing. Another valuable tool for transferring an image to my drawing paper is transfer paper—thin sheets of paper that are coated on one side with an even application of graphite. (See page 16 for more information.) Some artists like to keep a pencil sharpener on hand, but as I use mechanical pencils, this is unnecessary. I do keep a small piece of fine sandpaper nearby to resharpen tortillons or to blunt the end of a pencil, though. To shield areas of my paper from graphite or to anchor my drawing in place, I use artist's tape, which doesn't disturb the paper's surface. I also use a computer to display my reference photo (see below).

Setting Up Your Drawing Space

You don't need a studio—or even a drawing board—to start drawing. It is important, however, that you have a comfortable and well-lit space, preferably with natural light. Before I begin drawing, I lay out my work area, placing my artwork directly in front of me, my pencils to the right of the drawing (I am right-handed), and my remaining tools above the paper. Many artists prefer an easel, but I find that a flat surface provides better stability for my arm. When working from a photo, I often scan it and work while referencing the computer monitor, placing the computer directly in front of me, with my drawing paper on the table between the computer and me. This protects the photo from my graphite-covered fingers, and I can zoom in on areas of the reference.

Creating a Studio A studio can be located anywhere—from your home office to your kitchen table—but a north-facing room provides the best source of natural lighting.

DRAWING AND SHADING TECHNIQUES

Before you begin the projects in this book, it's important to understand the very basics of pencil drawing—from handling the pencil to blending and manipulating the graphite. These next pages feature a number of standard techniques that every pencil artist should be familiar with.

Holding the Pencil

I use two basic hand positions when drawing: the underhand position and the handwriting position. For the *underhand* position, I hold my palm almost parallel to the drawing surface with the pencil running under and across my palm. This places the lead at an effective angle to the paper for sketching, shading, and executing broad, sweeping strokes. For the *handwriting* position, I hold the pencil in the same way that I do for writing. I have the most control over the pencil in this position, and I can use the point for detailed and intricate work.

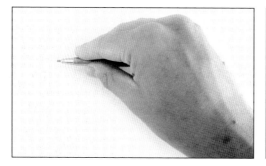

Underhand Position This is a useful position for sketching sweeping movements, such as those used for long hair.

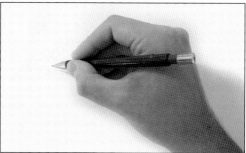

Handwriting Position This position affords plenty of control for drawing fine details, such as facial features.

Blending

Blending can be used to create many textures, but it's particularly useful when you want smooth tones or subtle pencil strokes. Experiment with various techniques, and learn to choose your tools based on comfort and the size of the blending area.

Using a Tissue For an overall smooth effect, gently rub over an entire area with tissue.

Using a Tortillon Tortillons can create lines over a large area, as shown, or smooth out tight areas.

Gradating

You can create a shaded gradation (from light to dark or dark to light) by switching to a harder or softer pencil, respectively, or by gradually changing the pressure applied on the pencil. The harder you press, the darker the stroke will be. By creating scales like those shown at right, you can see the range of *values* (the relative lightness or darkness of black) that various pressure amounts and pencil grades produce.

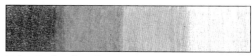

Value Scale: Changing Pencils This gradation of value begins with a 5B pencil, merges into a 5H, and finally ends with the white of the paper.

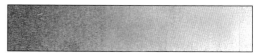

Value Scale: Smoothing the Tones For a seamless gradation, blend the tones with a tissue.

Building Form

When drawing a dog or any other subject, two main elements create the form: shading and texture. The values used to shade an object describe its lightness or darkness relative to the light source; the variation in these values transform a flat image into artwork that appears three-dimensional. Texture also produces the illusion of form: Simply vary the value and density of your lines to render the texture, depending on the direction and strength of the light source—always keeping the lines nearest to the light source lightest and thinnest, and darkening and thickening them as they curve into shadowed areas.

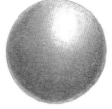

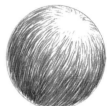

Creating Form with Shading By using darker values as you move away from the light source, you can give a sphere the appearance of form and depth. On the bottom sphere, the lines follow the contour of the curve; the darker and denser texture in the shadow areas communicate its form.

Negative Drawing

Negative drawing means defining an object by filling in the area around it rather than the object itself. This method is particularly useful when the object in the foreground is lighter in tone than the background. Negative drawing is extremely helpful when drawing hair. You easily can draw dark hair using lines, but how do you draw light hair? You draw the negative shadows between the hairs.

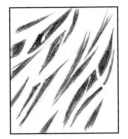

Using Negative Drawing for Hair Once the negative space is shaded, you can add texture and tone to individual hairs to give them more realism and depth.

Drawing with Erasers

Erasers can produce a number of exciting effects when used with graphite. To create sharp highlights, use the edge of a hard vinyl eraser. To create a defined edge, simply shade roughly up to the edge of an object, and then run a hard eraser along the edge to eliminate any pencil strokes that run beyond it. You also can use an eraser to lighten objects, suggesting distance. First draw both near and far objects with exactly the same values; then form tack adhesive into a ball and roll it over the far objects until you achieve the desired contrast. (See "Lightening for Distance" on page 40.)

Drawing Lines with an Eraser Quickly stroking the edge of a hard eraser across graphite results in a clear line that can be used to suggest highlights.

Creating a Crisp Edge One long swipe of the edge of a hard eraser will define the edge of a shaded area, as seen on the right side of this example.

Drawing Hair To create this hair texture, apply a solid layer of shading. Then use the tip of an eraser to pull out short lines in the direction of hair growth.

RENDERING HAIR

The basic categories of dog hair are long and curly, long and straight, short and curly, and short and straight. Roughness or smoothness of the hair also affects its appearance. There are many variations within each basic type of hair, but you should be able to adapt one of the techniques demonstrated in this section to draw any dog hair you wish. For the longer hair types, I'll show both a detailed method with definite areas of shadow and highlight and a quicker, sketchier method created simply with lines.

Long, Curly Hair

Detail Method

Step 1 Long, curly hair tends to flow in waves. Begin drawing wavy lines using an HB pencil, roughly following a consistent pattern of curvature while ensuring that the pattern isn't too rigid and exact. Be sure to overlap some hairs for realism.

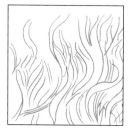

Step 2 Darken the areas in between the main clumps of hair using a soft pencil. Then suggest the strands within the clumps of hair nearest the viewer, using long strokes to communicate the length. Leave some areas nearly free of graphite to bring them forward visually.

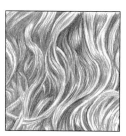

Sketch Method

Step 1 To draw the same hair with a freer, looser style, don't worry about positioning the hairs or other details; just sketch long, wavy lines, again following a general S-shaped pattern.

Step 2 Now rough in texture using lines. Rather than creating definite areas of highlights and shadows, simply place the lines closer together in shadowed areas and farther apart in lighter areas. When drawing any type of hair, always stroke in the direction of growth.

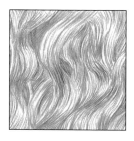

Long, Straight Hair

Detail Method

Step 1 Long, straight hair doesn't necessarily lay in perfectly parallel lines. In fact, the longer the hair, the more haphazard it's likely to be. With this in mind, draw long sections of hair, stroking in different directions and overlapping strokes.

Step 2 Carefully shade the dark areas among the hairs, and apply long, light strokes on top of the sections of hair. Then use tack adhesive to lift out some individual hairs, giving depth to the coat.

Sketch Method

Step 1 Draw light, rough, lines to provide guidelines for the sections of hair. Then use long, wispy strokes to gradually build up the strands along the guidelines. Place lines closer together for dark areas and farther apart for light areas.

Step 2 As with the detailed method, add highlights and depth by lifting out additional hairs using tack adhesive formed to a point.

Short Hair

Short, Straight Hair From a Dalmatian to a Doberman Pinscher, many breeds have coats with short, straight hair. This is the simplest type of hair to draw, as it generally is made up of only short lines. For a detailed rendering, draw many straight lines, all running in the same direction (in this example, on a diagonal). To give the impression of individual short hairs, draw pairs of lines, tapering the ends together to form a point for each hair. Keep your strokes quite free; try not to think about each hair, but let your hand randomly draw the lines.

Short, Curly Hair A few breeds, such as Poodles and Bichon Frises, have coats with short, soft, tight curls. A good way to draw this type of hair is to fill the area with even shading using an HB pencil, then blend with a tissue. For the highlights, use an eraser to lift out graphite using a random, circular motion. In this view, the light is coming from above, so the shadows are on the underside of each highlighted curl.

Other Types of Hair

Smooth Hair To draw the smooth, silky hair of a Yorkshire Terrier or Afghan Hound, you must make your strokes more uniform. Unlike the long hair of a Golden Retriever, the shiny hair of a Afghan Hound lays very straight. Draw long, sweeping, parallel lines, leaving lighter areas for highlights. As with any type of hair, avoid drawing the lines too uniformly in direction or value, which produces an unnatural look.

Fluffy Hair A puppy's hair is generally fluffier than a mature dog's hair. I've found that the same method I use for short, curly hair works well for puppies, although it will not work for every breed. Another approach is to create rough rows of hair that give the impression of hair fluffing outward, as shown above. Draw lines close together, following rows across the paper, and make some strokes longer than others to break up any distracting patterns.

FOCUSING ON FEATURES

Before creating a full canine portrait, it's a good idea to get to know the general shapes that make up each feature. As you practice rendering the features of a variety of dogs, notice the subtle changes in shape, value, and proportion that distinguish each breed.

Eyes

The eyes are possibly the most important feature when it comes to capturing the personality and character of an animal. Below I provide two basic viewpoints for drawing the eyes: a three-quarter view (turned slightly away from center) and a side view.

Three-Quarter View of the Eye

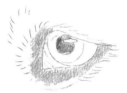

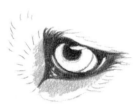

Step 1 Using an HB pencil, begin by outlining the main areas of the eye—the pupil, the iris, the eyelids, and the highlight. Also sketch the hair around the eyes. Almost all dog breeds have a very dark area of bare skin surrounding the eyeball, so shade this area with solid tone.

Step 2 Next, using a 2B pencil, block in the darkest values of the eye, including the pupil (avoiding the highlight) and the area surrounding the eyeball. As you shade, leave small highlights in the corners of the eye to convey the impression of a moist, glistening surface.

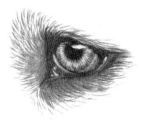

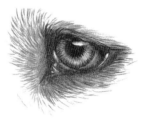

Step 3 Begin creating the pattern of the iris using an HB pencil, drawing lines that radiate outward from the pupil toward the outer edge of the iris. Also use the HB pencil to add more hair around the eye, following the direction of growth.

Step 4 Finish the eye with an H pencil, adding more tone to the iris and then lifting out some graphite to indicate reflected light. Also soften the highlight with a tortillon. Then continue developing the hair, stroking over the top of the lid and over the outer corner.

Side View of the Eye

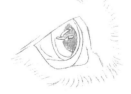

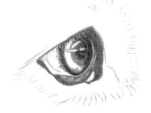

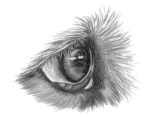

Step 1 From the side, the shapes that make up the eye are quite different. The iris and pupil appear elliptical, but the overall eye has a triangular shape. Start by delineating the main areas of the eye, including the highlights.

Step 2 Before blocking in darks, indent some lashes along the upper eyelid using a blunt needle or stylus. Then apply dark tone to exactly the same areas as in the front view. When you shade over the lashes, the indented lines remain white.

Step 3 Now add the midtones and lights. Use radial lines for the iris, covering it with a midtone. Then emphasize the highlights using tack adhesive, noting the direction of light. Finally, add the hair with short, tapering strokes.

Noses

There is a tremendous variation in size, shape, and even color of noses from one breed to the next. Below I'll draw the nose from two common viewpoints: a frontal view and a three-quarter view. Be sure to observe your subject from a variety of angles to truly understand the shape of its features.

Front View of the Nose

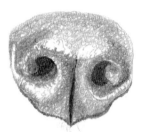

Step 1 Begin by using an HB pencil to sketch the shape of the nose, including the nostrils. Be sure to study your subject and draw the shape you really see—not the shape you expect it to be. Then add rough guidelines to show where the main areas of light and shadow will be.

Step 2 Next add tone with a 2B pencil, using tiny circular strokes to emulate the unique texture of a dog's nose. Darken the nostrils and the vertical crease through the middle of the nose. Then begin shading the rest with lighter layers of circles. Leave the highlight areas free of graphite.

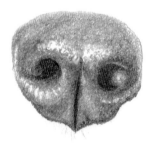

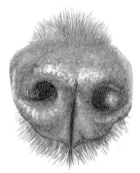

Step 3 Go over the entire nose with small circles to soften the texture slightly, but keeping the bumpy effect. Leave the top of the nose and the area under the nostril light to suggest the reflected light. To create the appearance of a wet nose, avoid blending the darks into the lights, instead allowing harsh separations.

Step 4 To connect the nose to the rest of the dog's face, begin adding the surrounding hair. As with the eyes, the hair grows away from the nose, with the darkest areas directly under and above the nose. The hair just below the nose is generally coarse, so keep these lines dark and short.

Three-Quarter View of the Nose

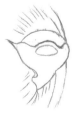

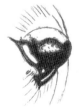

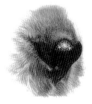

Step 1 Viewed from this angle, a dog's nose almost forms a V. Begin this puppy's nose by blocking in the light and dark areas using a 2B pencil. Also suggest the direction of hair growth.

Step 2 Use a 2B pencil to fill in the darkest areas and start establishing texture around the highlight with half-circle strokes. Indicate the position of the nostrils by placing a subtle highlight beneath them.

Step 3 Further build up the darks, and shade the slightly lighter curve along the left side of the nose. Then suggest the very fine, short hairs above the nose with a 2B pencil.

Ears

Ears vary greatly in the canine world—they can be long or short, dropped or upright, and long haired or short haired. Here I provide examples of two basic types of ears: the upright ear of a German Shepherd Dog and the dropped ear of a Pug.

Upright Ear

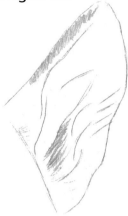 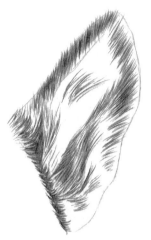 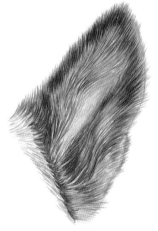

Step 1 The German Shepherd Dog has relatively large ears—especially given that they stand upright. In this example, we're viewing the dog's left ear straight on, so the shape is triangular. Begin by sketching the ear shape with an HB pencil, outlining the folds and mapping out some of the darker tones.

Step 2 Using a 2B pencil, begin adding hair to the ear, starting with the darkest hair around the base and along the upper-most edge. Let the hair dictate the form of the ear from now on, using very little shading. The hair grows upward and outward across the ear, with a hairless area along the inside flap of the ear.

Step 3 Go over the dark hairs with an HB pencil; this fills in the gaps with a slightly different tone, providing depth and thickness to the hair. Fill in most of the remaining gaps with strokes of a 2B pencil, applying very little pressure for the lighter areas. Finish by lightly shading the hairless area using a 2H pencil.

Dropped Ear

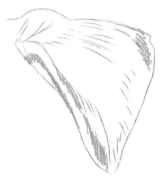 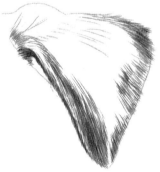 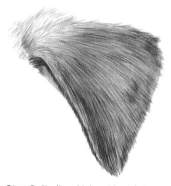

Step 1 In this example, we are again looking straight at the ear, so it appears triangular. Sketch a rough outline of the ear and scribble in shading to indicate the darkest areas using an HB pencil. Because the small ear of a Pug flaps over the side of the head, the skin around the ear canal is not visible.

Step 2 As with the example above, you want the hair, rather than shading, to dictate the form; so begin by adding the darkest hairs, which run along the shadowed underside of the ear and along the outer edge where the ear curls under. Keep your pencil strokes short to imply short hair.

Step 3 Finally, add the midtone hairs. Continue stroking in the direction of the hair growth, but try to make your lines a little erratic to avoid unrealistic patterns; for example, place the hairs closer to-gether in places. To unify the hair, apply a layer of 2H graphite over the entire ear, except for the very top left corner, where the light is strongest.

Paws

Paws vary in size and are covered with different types and lengths of hair, but the general structure is similar across all breeds.

Top View of Paw

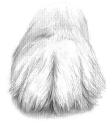

Step 1 Paws viewed from above vary, depending primarily on the dog's type of coat. For this paw with medium-length hair, use an HB pencil to outline and sketch in the direction and shape of the hair. The areas that indicate the shape are the shadowed gaps between each toe and the knuckles between the gaps.

Step 2 Next simply sketch in the hair using light strokes that mimic the length of the hair. The hair toward the bottom of the paw is darker because it is in shadow. Use diverging lines to part the hair between each toe, lightening your strokes as you move outward.

Underside of Paw

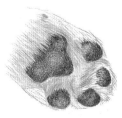

Step 1 The main features of the underside view are the dark pads. There is one large, central pad, plus a pad for each of the four toes. The texture of the pads is similar to that of a dog's nose, so make the same type of circular strokes with a 2B pencil. Sketch short lines for the hair around and between the pads.

Step 2 Continue adding small circles to the pads using a 2B pencil, gradually building up the shadow along the edges and leaving the lighter areas with just one layer of circular strokes. This texture contrasts nicely with the smooth strokes of the surrounding hair.

Whiskers

There are a number of ways to suggest whiskers—but many whiskers are light in color and often nearly translucent, so two of the three methods below involve *not* drawing them.

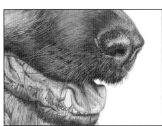

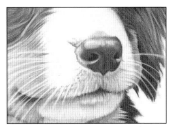

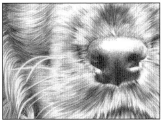

Indenting Method For light whiskers against dark hair, use a blunt tool to indent the whiskers; then shade over them. Continue the whiskers into lighter sections using a sharp HB pencil.

Erasing Method For thicker whiskers, remove the graphite with the point of an eraser. This method is best suited for large or close-up drawings.

Negative Drawing Method To create thin or thick whiskers without disturbing the paper's surface, outline the parallel shapes of each whisker. Avoid stroking over them when adding hair.

UNDERSTANDING BASIC PROPORTIONS

Proportion refers to the relationship of size between two or more elements of a composition. The proportions of an adult dog—for example, the size of its head relative to the size of its chest—differ from those of a puppy. And the proportions vary from breed to breed. To effectively communicate the age and breed, you must learn to depict the proportions accurately.

Adults Versus Puppies

When drawing a puppy, people commonly make the mistake of simply drawing a small adult dog. Although a puppy possesses all the features of a mature dog, its proportions are quite different, as illustrated in the side-by-side comparison below.

Building the Basic Shapes Compare the sizes and relationships of the head, chest, and hips of an adult Golden Retriever (left) with those of a puppy (right). The puppy's head is much larger in relation to its body, and the three parts are closer together.

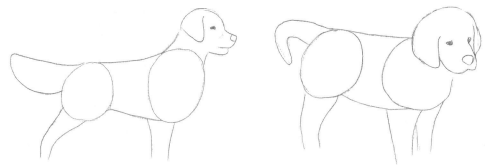

Outlining the Torso and Extremities After connecting the basic shapes and adding the legs and tail, it's easy to see that the adult dog on the left has a leaner build with longer legs, and its muzzle is longer and narrower.

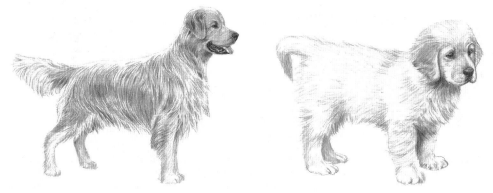

Adding the Coat and Features In these finished sketches, the differences between the puppy and the adult are unmistakable: The puppy's features—ears, eyes, nose, and paws—are all much larger in relation to its body, and the puppy's hair is softer and fluffier.

Breed Differences

To learn the subtleties of a breed's proportions, it's helpful to compare several different breeds side by side. When comparing adult dogs of different breeds, it's often the relative size and details of the features—for example, the shape of the muzzle or the length and color of the coat—that differentiate one breed from another, rather than the relationships of the head, chest, and pelvis. There are more numerous dog breeds that can be covered in this book, but these few examples will help you practice identifying the subtle but essential differences that give each breed its own look.

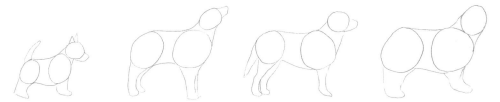

Basic Shapes Comparing the basic shapes of (from left to right) a West Highland White Terrier, a Border Collie, a Labrador Retriever, and a Bearded Collie, you can see that there is little difference in the size relationships of the head, chest, and hips, even though these breeds vary in overall size.

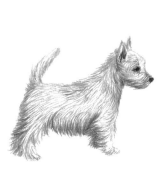

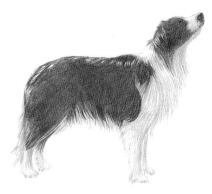

West Highland White Terrier The Westie is a small, fairly compact dog with short legs and an upright tail. The ears are small, pointed, and erect, adding to its alert expression. It has a coarse white coat of medium length.

Border Collie A medium-sized dog, the Border Collie has a long body and a low-set tail that hangs down. Its long muzzle tapers slightly to its nose. The ears are usually held half-erect.

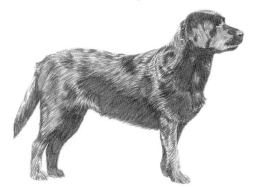

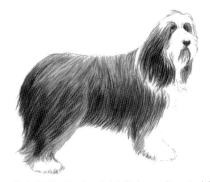

Labrador Retriever The Lab can be black, chocolate, or yellow. It is similar in size to the Border Collie, but it's heavier, thicker, and blockier with a short, dense coat. This dog's powerful neck supports a broad head with a wide nose. The tail is thick near the body but tapers to a point.

Bearded Collie The Bearded Collie is a medium-sized dog with a shaggy coat. It has a broad head with a strong muzzle and a squarish nose. The ears lie close to the head, and its long, ever-wagging tail is carried low with an upward curl at the tip.

DRAWING FROM PHOTOGRAPHS

Drawing from life is challenging when the subject is an animal that doesn't sit still for long periods of time. Drawing from photographs certainly makes the process simpler, but capturing a clear photograph that makes for an interesting composition can be quite a mission. Any dog owner will tell you that getting a dog to sit still is a difficult task indeed. The only time a dog is not in motion is when it's eating or sleeping, and neither of these makes for a particularly interesting portrait. The key is, put simply, patience! Below I provide some tips for setting up and taking reference photos.

Setting Up

The ideal location for a photograph depends on the type of drawing you plan to execute. If you're aiming for a simple portrait of a dog, a plain background (or none at all) would be most suitable. Grass or shrubbery in a backyard is ideal for this. But if you plan to place greater emphasis on the background, look for one that contrasts with the dog's coat; use a dark background for a light-colored dog and a light background for a dark-colored dog. And if you can't bring the dog to an ideal location, consider combining photo references, using one for the subject and another for the background.

Take advantage of natural outdoor lighting when possible, as this will eliminate the need for a flash and any chance of the red-eye effect. I prefer to position the dog so that the sun or light source is in front and slightly to the side, as I've found that this creates interesting shadows on the body, which is especially important for light-colored dogs.

Once you're ready and the camera is set up, try to attract the dog's attention with a toy or object. A squeaky toy is an effective tool for getting a dog to stare alertly wherever you hold it, and a treat often has the same effect. If the dog has been trained to sit or stay on command, use it to your advantage. And the task of photographing a dog is made much easier if you have help. It's best to have three people on the scene: one to take the photo, one to stand next to the dog so it isn't constantly running to the camera, and one to hold treats or a squeaky toy.

Drawing from a Photograph

Once you have a reference photo, you can approach the drawing in several ways. Drawing freehand works well for loose drawings, as this style doesn't require great precision or the exact placement of features. But for detailed drawings, it's best to transfer the basic outlines of the image so the proportions are accurate. You can do this using the grid method (see also page 17) or by using transfer paper.

My preference is to transfer the outlines and shapes using the *grid method,* which helps you break down the picture into smaller, less intimidating segments. To do this, draw a grid of squares over the reference photo. Then draw a corresponding square grid over your drawing paper; the reference and your drawing paper must have the exact same number of squares, so even if they're not the same size, the original image and the drawing paper must have the same proportions. Once you've created the grids, simply draw what you see in each square of the reference in each square of the drawing paper. Draw in one square at a time until you have filled in all the squares. One-inch squares are great to start with, but just remember that the larger the squares, the more freehand drawing is required.

If you prefer to work with graphite transfer paper, place a sheet of transfer paper over the drawing paper (graphite-side down); then place the photograph (or a photocopy of the image) over the transfer paper. Use heavy pressure to trace the major shapes of the image—directly on the photograph or photocopy—with a ball-point pen, transferring the lines onto your drawing paper.

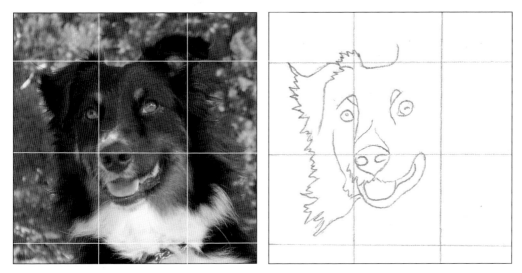

Grid Method Using the lines of the grid squares as reference points, you can accurately position the features of your subject. But make the grid lines light; you'll need to erase them when you finish transferring the drawing.

Deciding What to Keep

It's rare that a reference photo turns out exactly how you'd like to render the subject. You'll almost always want to add elements or leave objects out to improve the image, enhancing the most important features or altering the mood of the scene according to your taste.

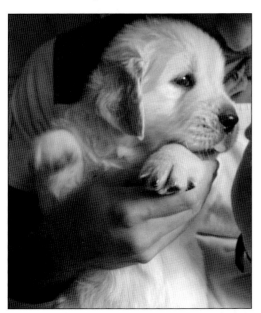
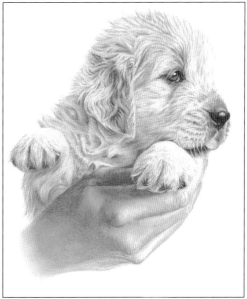

Changing Your Photo In this reference of a Golden Retriever puppy (above left), I like the way the hand is holding the puppy, but the rest of the person's body isn't working for the composition. I decide to eliminate the human body, leaving a white background to soften the scene. The puppy's coat is very light, so the darker hand provides an effective contrast. The pup's right paw is blurry in the photo (even if you can hold a puppy still, inevitably at least one part will be moving), so I also sharpen this in the final drawing.

ESTABLISHING A COMPOSITION

Composition is the arrangement of elements within a space. An effective composition leads the viewer's eye into the drawing and toward an area of interest, or the *focal point*. A poor composition often is uninteresting and lacks a natural, balanced feel—the drawing might be too symmetrical, it might have too much visual weight on one side, or the subject might be too small or large within the *picture plane*, the two-dimensional surface within the four sides of your paper. Before you begin creating a portrait, you'll want to work out your composition to ensure that the elements of your drawing come together in a dynamic way. When approaching a subject, I immediately make two important decisions about the composition: whether I want a close-up portrait or a full-body drawing, and whether I want to incorporate a background.

Portrait Without Background

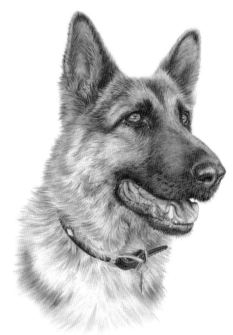

Most often I choose to create a portrait that consists of only the head and shoulders. Generally the dog's head is seen from a three-quarter view, which avoids the symmetry of a frontal view but gives a greater sense of intimacy than a profile view. With this style of composition, I fade out the bottom edge of the drawing to avoid any harsh lines that lead the viewer's eye off the paper. This composition also gives a high level of focus to the facial features, as there are no distracting background elements.

Creating a Feel The soft edges and distant gaze of this German Shepherd Dog give this drawing a nostalgic quality.

Portrait With Background

When drawing a dog with very light hair, I often choose to add a background. This gives me the opportunity to include a range of values for interesting contrasts that set off the dog from the white paper. I also create contrasts through shape; for example, here I juxtapose the tight curls of a dog's coat against long blades of grass. Including a background also gives me greater freedom in terms of the dog's position; even a frontal view can be dynamic if framed properly with surrounding elements.

Framing the Subject I enhance this frontal view of a Shih Tzu puppy by framing the face with a contrasting foliage pattern.

Full-Body Drawing Without Background

A full-body drawing without a background is an excellent way to illustrate the specific attributes of a breed. This type of composition is most effective with the profile view, which showcases the length and musculature of the dog. The lack of a background keeps the focus on the dog's stance, as well as on its conformation.

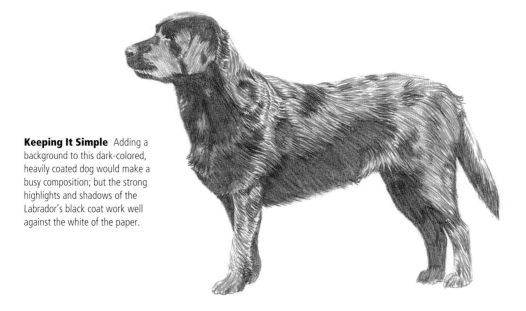

Keeping It Simple Adding a background to this dark-colored, heavily coated dog would make a busy composition; but the strong highlights and shadows of the Labrador's black coat work well against the white of the paper.

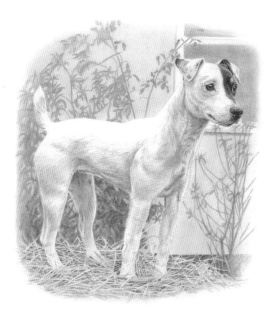

Full-Body Drawing With Background

When rendering a full body with a background, values become even more important. If I'm working with a light-colored dog, I choose medium-to-dark values that contrast with the coat. Likewise, if I'm working with a dark-colored dog, I opt for lighter tones that don't compete with the subject. Doing this will keep my subject from blending into its surroundings. I also use the background elements, like the curving ivy, as tools to guide the viewer's eye to the focal point of the piece: the head.

Creating Contrast In this drawing of a Parson Russell Terrier, I make sure that the dog's coat never merges into the background. Because the coat is white, I set it against dark foliage. However, by the same reasoning, I lightly shade the wall next to the shadowed underside of the neck.

APPROACHING PORTRAITURE

Capturing the character of a subject is in many ways more important—and more challenging—than rendering a strict photographic image. Although a full-body portrait may take advantage of stance to reveal a dog's character, a head-and-shoulders composition relies on the tilt of the head and the facial expression, allowing the artist to focus on highlighting the features that give the dog its personality, such as this Golden Retriever's alert ears and affectionate eyes.

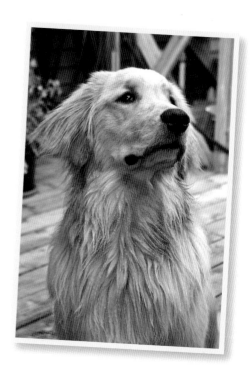

Eliminating Distractions This background is full of repetitive diagonal lines that may lead the viewer's eye away from the face and out of the drawing. Also it is a similar value to the dog's hair, so the dog may get lost in the drawing. For these reasons, I chose to draw the dog without a background.

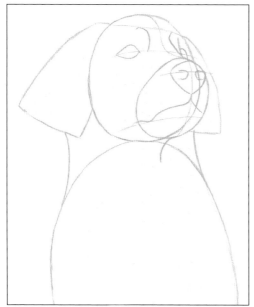

Step 1 Using my photo for reference, I create a freehand sketch using an HB pencil. I begin with the basic shapes, indicating the chest, head, ears, and muzzle. Once I'm satisfied with the general layout, I place the eyes, nose, mouth, and brows. I stand back from the sketch, eye it as a whole, and adjust accordingly.

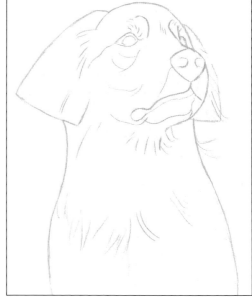

Step 2 Once I have all the features placed accurately, I erase the pencil lines that are no longer needed. Using an HB pencil, I add some guidelines to map out the direction of the hair growth in key areas, such as on the neck and chest, around the eyes, and on the ears. I also begin to refine the shapes of the eyes.

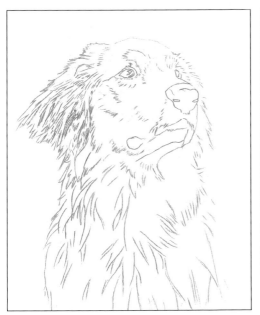

Step 3 At this point, I use the general layout of features and proportions as a map to create a detailed line drawing of the Golden Retriever. Using short, tapering strokes that correspond with the length of the dog's hair, I indicate the clumps and layers of hair. As I refine the line drawing, I erase the harsh guidelines.

Step 4 I begin shading the ear by filling in the darkest areas with a 2B pencil and defining the light hair through negative drawing. Switching to an HB pencil, I add midtones in the lower ear. Then I shade with an H pencil, gradually decreasing the pressure as I work toward the top of the ear. I leave the lightest hairs unshaded.

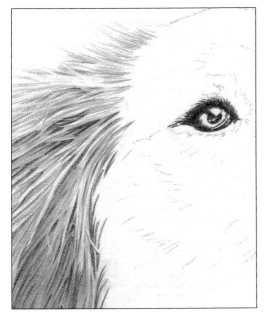

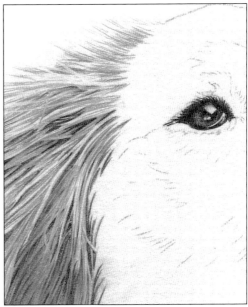

Step 5 Moving on to the eyes, I use a 5B pencil to add tone to the dog's right pupil, shading around the highlight. I also build up the dark values around the eyes. Then I address the dog's left eye in the same manner.

Step 6 Still using the 5B, I darken the iris using lines radiating from the pupil, and I add a light layer of shading over it. I use the tip of a tortillon to softly blend the strokes, creating a crescent of lighter tone in the corner of the eye.

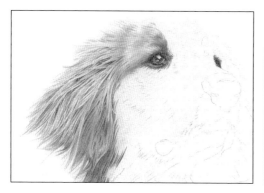

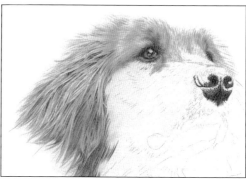

Step 7 Now I switch to a 2H pencil to add hair around the dog's right eye, connecting it to the ear using strokes that follow the direction of growth. I make the hair in the dimple of the dog's brow a bit darker, as shown in the photo.

Step 8 I continue with the same pencil and technique as I work across the forehead and around the other eye, paying careful attention to the pattern of hair growth. I fill in the darks of the nose using a 2B pencil and small, circular strokes (see page 11).

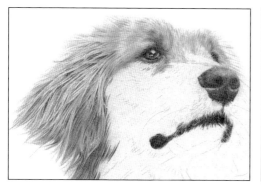

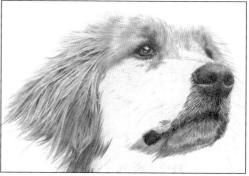

Step 9 I switch to an HB pencil and apply light layers of circular strokes over the nose, working around the highlights on the lower edges of the nostrils and the top of the nose. I add very dark tone to the mouth, keeping the edges jagged to create the impression of hair growing over the lips.

Step 10 Using a 2B pencil, I continue adding the hair, filling in the area around the mouth with midtones. The hair under the nose and just above the mouth is short and coarse, so I reflect this with darker, thicker, and shorter strokes.

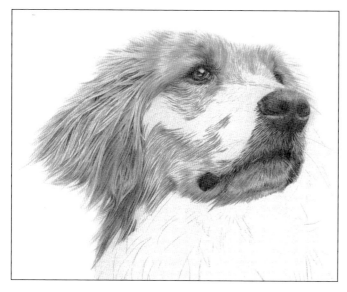

Step 11 I use a 2H pencil to carry the tone under the eye and on the lower cheek. As you add the hair, make sure the value of each area corresponds to the form of the subject. I also examine my reference carefully so I can re-create the pattern of hair growth. I notice that it scoops under the eye and moves downward into the neck.

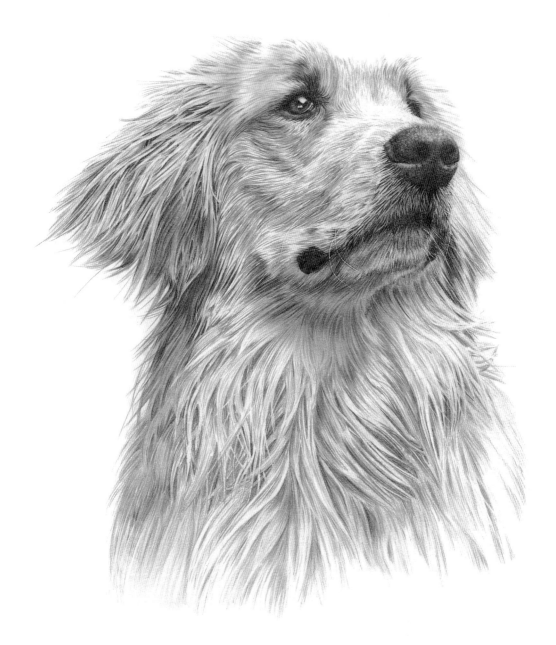

Step 12 I finish filling in the hair on the cheek, around the nose, on the muzzle, and under the jaw using an HB pencil, varying the pressure to create shadows and highlights that reflect the underlying skeletal structure. As I move toward the bridge of the nose, I switch to an H pencil and lighten my strokes until they are almost indiscernible. The remainder of the body is fairly straightforward. I revert to more negative drawing, filling in the darker areas first using a 2B pencil. As this area isn't in shadow, the darkest areas are in the midtone range. I use long, sweeping strokes to suggest the texture of the chest, using an H pencil and light strokes in the direction of hair growth. To complete the drawing, I gradually fade out the bottom area of hair by lifting out graphite with tack adhesive, creating a soft edge.

INCORPORATING BACKGROUNDS

To add interest to your composition, try working elements of the canine's environment into the drawing. You'll want these extra elements to enhance the focal point (the dog)—not overwhelm it. To keep the environmental elements in check, avoid giving them too much visual contrast. Render them with middle values, reserving the lightest lights and darkest darks for the main subject. Here, incorporating the grass and flowers adds a variety of textures and patterns that effectively contrast the Shih Tzu puppy's soft coat.

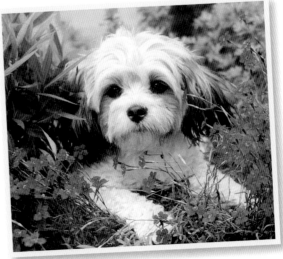

Framing the Face The center of interest in a pet portrait is almost always the face, so it's a good idea to use elements of the background to "frame" the face. For example, in this photo, the foliage cups the face with a U shape.

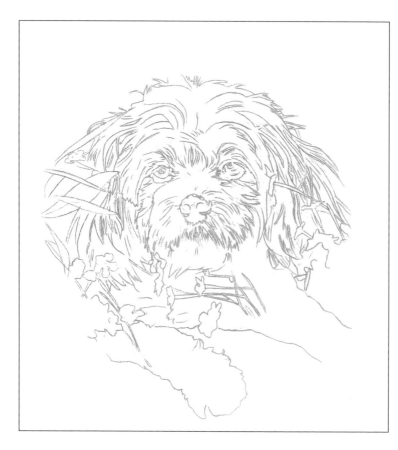

Step 1 First I use the grid method (see pages 16–17) to transfer the outlines of the Shih Tzu onto my drawing paper. I include all the major lines, describing the direction of hair growth and delineating some of the long leaves on the left. Using an HB pencil, I sketch only the foliage that directly affects the Shih Tzu, as my priority at this stage is to define the dog. I always avoid excessive erasing as I want my final drawing to have a clean look, so it's important that I make any adjustments to the line drawing now.

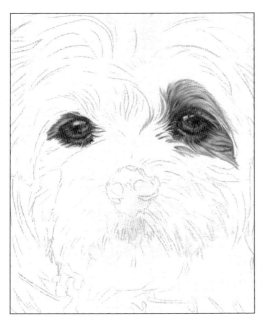

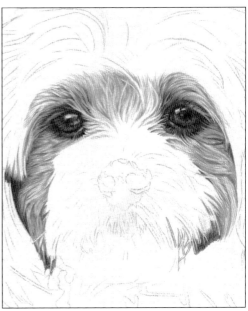

Step 2 Using a 5B pencil, I render the eyes. I apply the darkest tones on the rims around the eyes and in the pupils. Working around the highlights, I apply radial lines in the irises and smooth over them with a tortillon. I move into the surrounding hair with an HB pencil, stroking in the direction of hair growth.

Step 3 I use the same method to complete the hair in shadow, following the wave pattern of the hair and tapering the strokes at the ends. I avoid making uniform strokes, instead varying the thickness and spaces between them. As this is the darkest area of hair, I build up another layer of shading with an HB pencil.

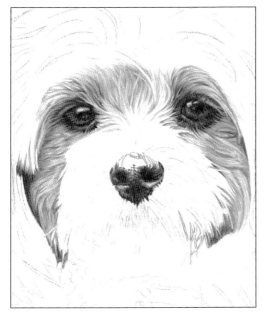

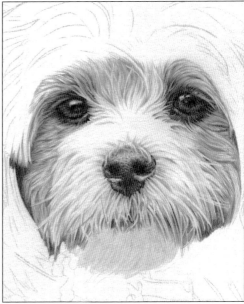

Step 4 After I finish the shadow areas on the face, I move onto the nose. Keeping in mind the direction of light, I use a 2B pencil to place the darkest values, applying circular strokes to the lower, shadowed part of the nose and in the nostrils. I'm careful to maintain the highlights on the top of the nose and along the bottom edges of the nostrils.

Step 5 Once I'm satisfied with the values in these first features, I "ground" them by adding hair detail over the entire face, keeping the top of the muzzle light. Using an HB pencil, I apply heavier strokes for the line of the mouth and stroke an even layer of graphite over the chin. I notice that the nose highlight is too strong, so I add a layer of graphite over the top to tone it down.

Step 6 Still using an HB pencil, I strengthen the values where needed as I work—it is easier to darken a value than it is to lighten it, so you don't want to start out too dark. Next I work on the ears, starting with the darkest values. Using my reference as a guide, I keep the hair lightest where it catches the most light. Next I stroke in some hair on top of the head, leaving the majority white, as it's directly in the path of the light. As I draw the hair, I stroke around the outlines of the leaves and flowers, defining their shapes with negative drawing.

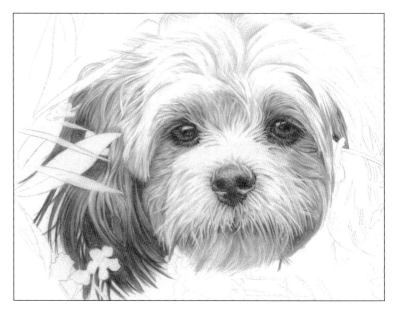

Step 7 I complete the ears, creating a gradation from light to dark as I move toward the tips by switching to a 2B and applying more pressure as I move down. I give the longer hair on the ears a messier look by adding thick, slightly curving chunks of hair. When I add the hair of the dog's left ear, I again draw around the outlines of the foliage to create their shapes. Then I add a thin layer of graphite below the chin and over the neck, toning the area evenly by smudging with a tortillon. (See "Smudging" below.) Then I use tack adhesive to pull out the shapes of the flowers and foliage in this area.

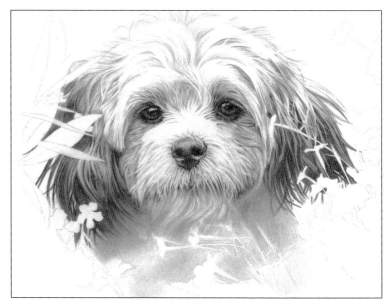

Smudging

Smudging creates soft blends that are perfect for depicting shadows on fluffy hair. Simply use a tortillon, blending stump, or chamois cloth to rub the graphite gently into the grain of the paper. If needed, you easily can lift out areas of smudging using tack adhesive, as shown.

Step 8 With the head nearly complete, I begin filling in the flowers and leaves in the foreground with an HB pencil. I give them a medium value between the lights and darks of the puppy's hair so they stand out. I make the flowers in front of the neck a bit darker to contrast with the light hair. I give the flowers and stems some dimension by darkening the undersides and keeping the upper areas light, as they're highlighted by the light source above.

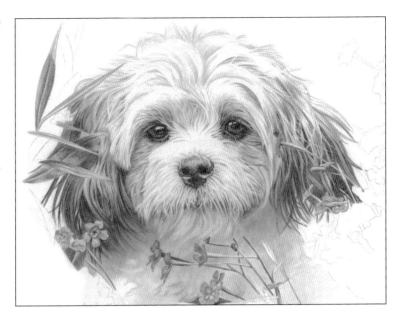

Step 9 Now I use negative drawing to add the grass in the foreground. Using an HB pencil and a dark value (about the same value as the darks of the ears), I shade around the blades of grass, filling in all of the negative space to define the edges.

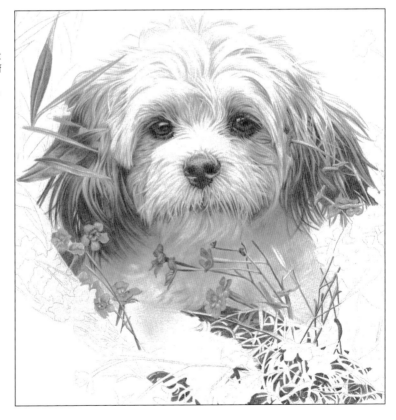

Step 10 I continue using an HB pencil to add tone to the grass in the foreground, varying the values on the blades to suggest depth. I keep the range of foliage values lighter than the darkest darks of the puppy (the eyes and nose) but darker than the puppy's lightest values (the top of the head and the muzzle). This keeps the greatest contrasts on the center of interest—the puppy's face.

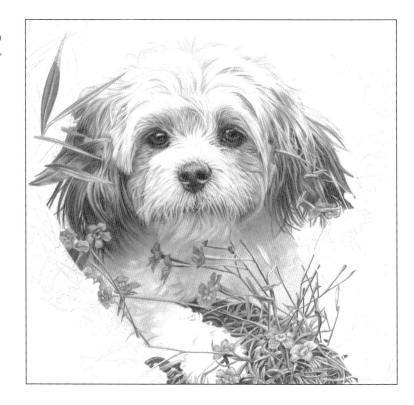

Step 11 I continue developing the foreground flowers and grass with an HB pencil. There is an interesting texture emerging, with the long, straight blades and stems contrasting with the round, delicate petal shapes. Then I add the long leaves and flowers on the right side of the composition. I set these elements off from the ears, making sure that the values of the leaves and flowers don't blend into the values of the hair.

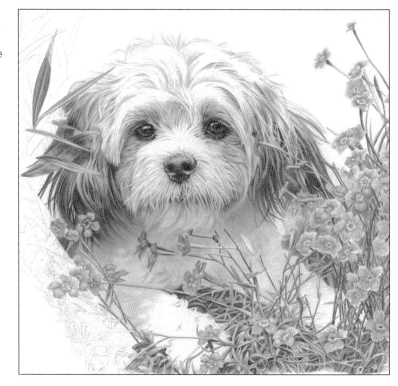

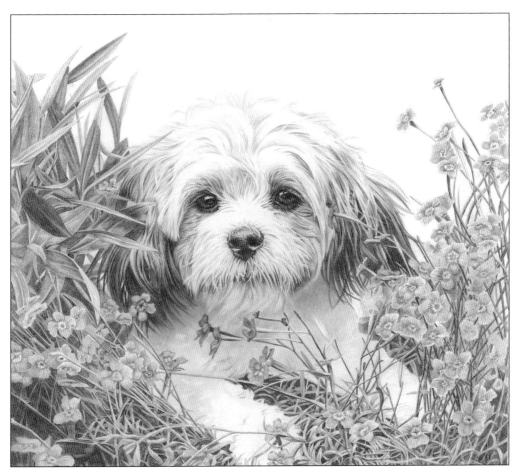

Step 12 I complete the leaves and foreground flowers on the left, maintaining the range of middle values as mentioned in step 10. The more simple, uniform texture of the puppy is now framed with intricate details and lines. Additionally, the darkest and lightest areas have been reserved for the puppy's face, drawing in the viewer's eye with extreme contrasts. Now I assess each area, adjusting the values as necessary. To darken an area, I simply use a 2B pencil to add layers of graphite; to lighten an area, I gently dab with tack adhesive to pull out graphite.

Incorporating Clusters of Leaves

Clusters of leaves provide a dramatic background with opposing lines and contrasting values. The resulting diagonals move the viewer's eye throughout the area and ultimately act as a tool to guide the viewer's eye toward the center of interest: the puppy's face.

ACHIEVING A LIKENESS

Capturing a likeness can be one of the greatest challenges for an artist, yet it also can be incredibly rewarding. The foundation of a successful portrait is careful observation coupled with a thorough under-standing of the head's form. Take time to study the subject's shapes and proportions. The German Shepherd Dog's high-set ears take up almost half of the vertical area of the face. The large muzzle narrows gradually toward the blunt tip of the nose, with a gentle sloping along the bridge. The short hair of the face closely follows the form of the head and neck. In addition to breed characteristics, take notice of any elements that make this particular dog unique, such as the mole next to its mouth.

Focusing on Details Including a dog's accessories, such as a collar and tag, can help you personalize a portrait even more!

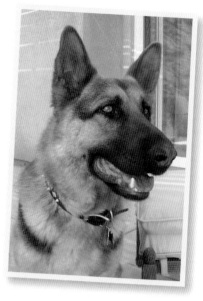

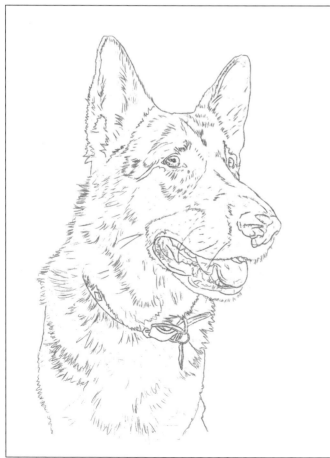

Step 1 For this drawing, I decide to leave out the background and focus solely on the shepherd's noble expression. I use a sharp HB to create a freehand outline, beginning with basic shapes and then honing them into a detailed outline. I use a drawing compass to compare proportions from the reference photo with the proportions in my sketch to ensure that they match. This also can be done with a ruler, but I find the compass to be quicker and easier. Once I'm happy with the basic outline, I draw short lines to indicate the growth direction of the hair, and I map out the areas of greatest contrast.

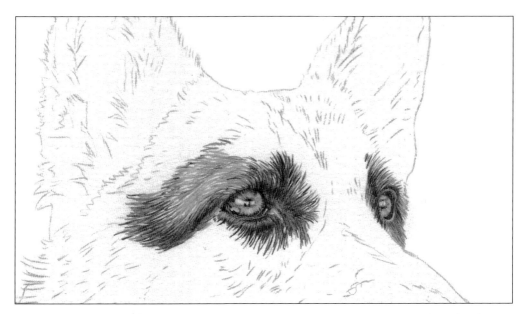

Step 2 I shade the darkest parts of each eye using a 2B pencil, leaving a highlight across the pupil and iris. Then I add midtone lines radiating from the pupil for the iris. Working around the highlight, I use an H pencil to cover the eye with a layer of shading. I indicate the hair surrounding the eyes with lines curving outward, switching to an HB for the lighter areas of the eyebrow. The gaps between the lines provide highlights.

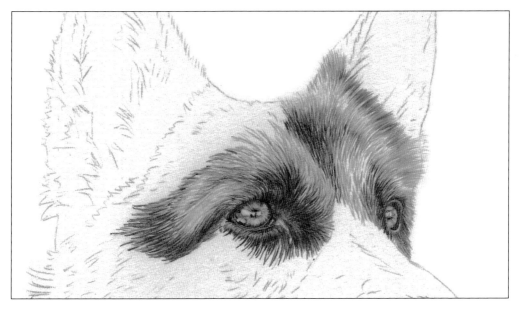

Step 3 I progress outward from the eyes, working up and over the forehead and into the dog's left ear. There is a darker patch of hair in the middle of the forehead, so I apply this first, using a 2B pencil to draw the lines in the direction of hair growth. Then I switch to an HB for middle-value areas of the hair, and I use an H to create the lightest sections. For the lightest highlights, I let the white of the paper show through.

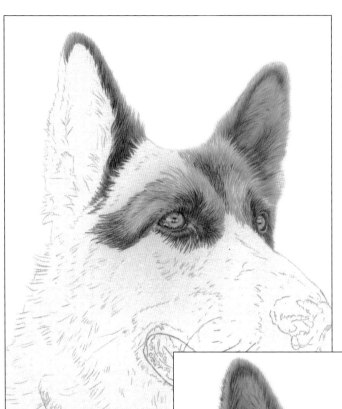

Step 4 The outer edge of the dog's right ear is very dark, so I use heavy pressure and a 2B pencil to apply tapering strokes that suggest small tufts of hair. I leave the rest of the ear free of graphite for now; I will finish it in the next step. Now I switch to an HB pencil to render the left ear, which is lighter in value.

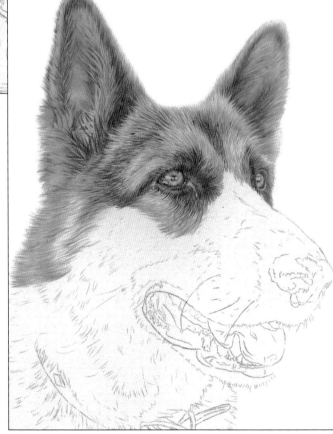

Step 5 For the smooth skin inside the ears, I shade with an HB pencil and then blend with a tortillon. Then I draw the hair over this shading, varying the values within the hair and adding shadows between the clumps of hair. I progress down the side of the head using an HB pencil, letting some of the paper show through for lighter areas.

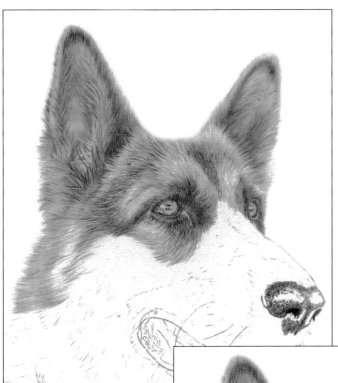

Step 6 I use a 2B pencil to draw the nose, making a series of small, dark circles to create the unique texture. I leave the highlight areas white. Next I concentrate on darkening the nostrils and the crease down the middle of the nose. Then I finish the nose by applying some lighter circles to the "white" sections on top and under the nostrils. Before I move on to the muzzle, I use a blunt tool to indent some whiskers and coarse, longer hairs below the nose. (See step 7 for placement.)

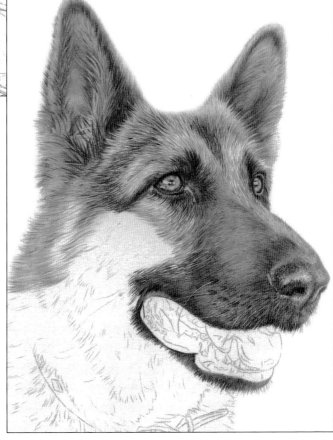

Step 7 Using close, short strokes that move away from the nose, I fill in the muzzle, changing the direction of my strokes near the mouth. There is actually little detail involved in the hair; accurately depicting the direction of hair growth is the key. Now I use a 5B pencil to darken the hair along the edge of the mouth.

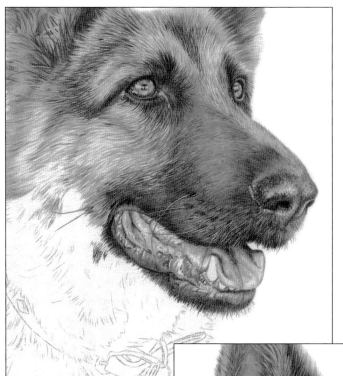

Step 8 With the muzzle defined, I move on to the inside of the mouth, shading the tongue with an HB pencil and blending with a tortillon for smooth transitions. I add tone to the gums and lips using a 2B pencil, taking care to leave patches of white for strong highlights that suggest wetness. I darken the whiskers where they overlap the mouth for continuity. I leave the teeth free of graphite. Still using an HB pencil, I fill in more hair on the cheek, darkening two lines to form a V shape near the corner of the mouth. (This suggests whiskers sprouting from the mole seen in the reference photo.)

Step 9 I finish filling in the hair on the cheek with an HB pencil, lightly shading over the V shape so it's visible underneath. I continue the hair pattern down the neck, drawing sections of hair that roughly follow the direction of growth. As the hair is longer here, it's important to show its flowing nature by making the strokes less uniform. The German Shepherd's collar adds a bit of interest to the lower area of the drawing. I use a 2B to shade it, working around the hair that flows over the top of the collar. Then I switch to an H pencil for the shiny metal pieces.

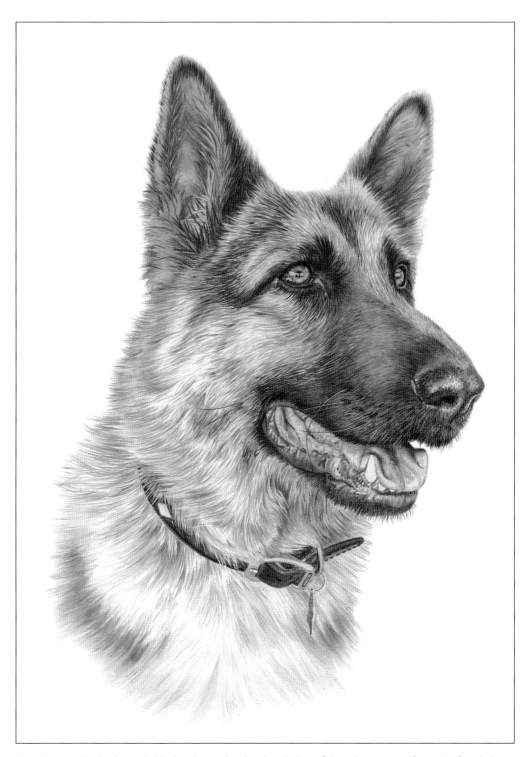

Step 10 I complete the drawing by blending the pencil strokes along the base of the neck, creating a soft transition from the hair to the white background. The bottom section actually is more paper than it is pencil—there are just enough pencil strokes to imply the shape and direction of the hair; this allows me to avoid a harsh finish line to the drawing and reinforces the German Shepherd Dog's happy, attentive expression as the focal point of the piece.

APPLYING ATMOSPHERIC PERSPECTIVE

When including a background scene in a drawing, you will want to employ the rules of *atmospheric perspective* to create the illusion of distance. The rules of atmospheric perspective state that, due to particles in the air, objects in the distance appear less distinct and with softer edges than they would if in the foreground. For this drawing, I've chosen to complement the close-up of a Border Collie's face with a background that portrays the Border Collie herding sheep in a pasture. Notice how the background elements are lighter in value and less detailed—a perfect example of atmospheric perspective!

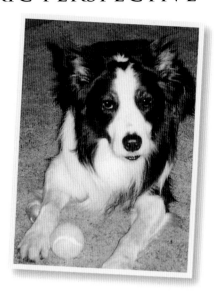

Pulling Out Information I will draw only the face and chest of a Border Collie, so although this full-body shot is not an ideal pose, it will work nicely as a reference for this composition. I simply will leave out any visual information that I don't need.

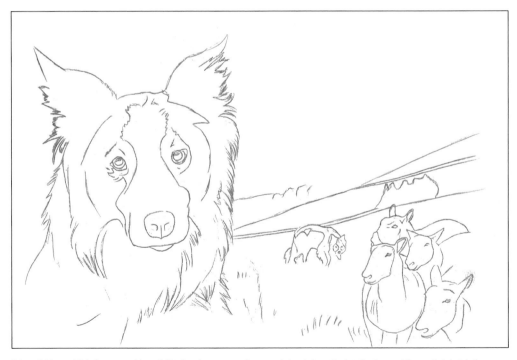

Step 1 To establish the composition of this drawing at an early stage, I sketch it out in detail using an HB pencil. I sketch the Border Collie portrait freehand on the left side of the paper, and then I add a distant scene on the right, using a second reference. The distant scene depicts the Border Collie herding sheep—draw the sheep in the foreground with the dog behind, herding the sheep toward the viewer.

Step 2 I address the portrait section of the drawing first, starting with the darks of the eyes and nose. I blacken the pupil with a 2B pencil but leave strong, curving highlights across the tops of the irises to suggest the spherical shape of the eyeballs. Then I fill in the iris, adding lines that radiate from the pupil. I smooth over these elements of the eye with a tortillon, creating a soft, glossy appearance. I also darken the rims of the eyes and add tone to suggest the eyelashes. Then I lay down the initial shading of the nose using circular strokes that convey a bumpy texture. I blacken the edges and nostrils, then add the midtones, retaining the highlights.

Step 3 I continue adding texture to the nose using a series of small circular strokes, still careful to maintain the highlights. Then I begin blocking in the hair, filling in the darkest areas first with one dark value and a 5B pencil. Following the growth of hair, I shade with thick strokes using a dull 2B pencil, tapering the ends as they move into the lighter areas of the coat.

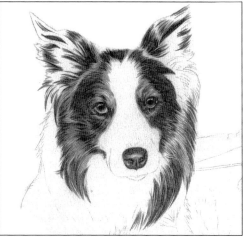

Step 4 Still using a dull 2B pencil, I finish adding the darkest areas of hair, moving into the ears, around the eyes, and along the edge of the ruff. Looking at my reference for guidance, I leave the shiny highlights of the black coat free of graphite, creating gaps in the strands of hair.

Step 5 Now I fill in the midtone areas using an HB pencil. I bridge the gaps between the dark areas with fine strokes that are farther apart than those previously applied, decreasing my pressure on the pencil at the lightest points. I also stroke in curves around the eyes and along the top of the white marking, softening the transition between the white and black hair.

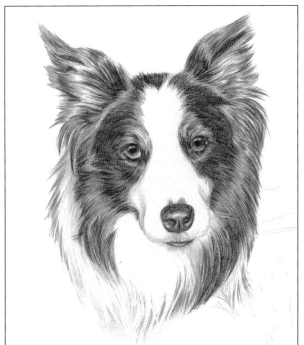

Step 6 I continue working over the ears, adding fine midtones lines with an H pencil. I also add strokes to delineate the edges of the hair, tapering the ends to suggest small clumps. I darken the mouth and create shadows just above and below the nose, as well as the shadows that show the curvature of each cheek. Along the bottom edge of the white ruff, I suggest the wave in the hair with light, tapering strokes. I leave the rest of the white coat free of graphite; the viewer's imagination will fill in the gaps.

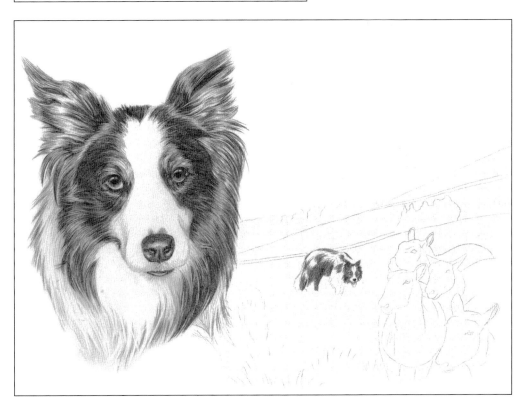

Step 7 I begin the background scene with its most important element: the Border Collie. The dog is in the distance, so I won't have to include as much detail—just enough to make it appear to be the same dog as in the portrait. I fill in the darkest areas of the dog using a 2B pencil, avoiding the highlights and taking care to match the white marking on the face.

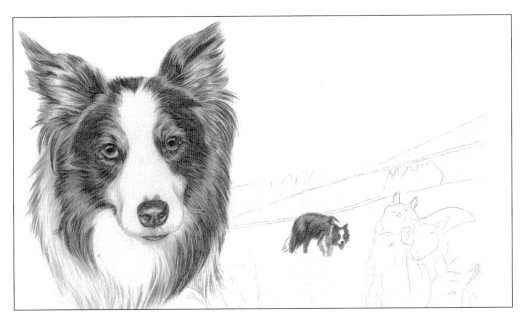

Step 8 To complete the dog in the background, I add the midtones to the back and legs using an H pencil. The feet are hidden in the grass, so I don't worry about rendering them. To capture the spirit of the breed, I keep the head of the dog low, as if it is stalking the sheep, ready to spring into action if one goes astray.

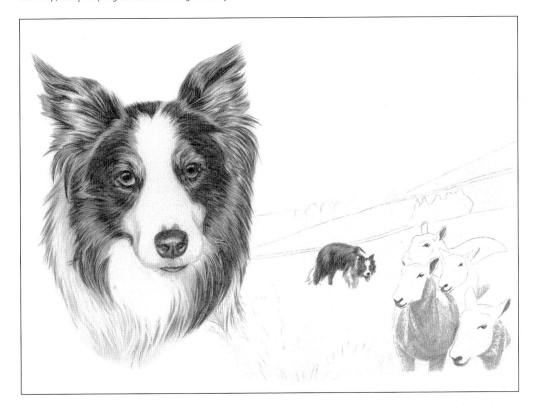

Step 9 Now I focus on the sheep. I add the darkest areas first, including the eyes, noses, mouths, and inner ears. I also begin rendering the wool using circular strokes and an H pencil, applying heavier pressure over shadowed areas. I keep the values in the middle range because I don't want too much detail or darkness to pull the viewer's eye away from the main portrait.

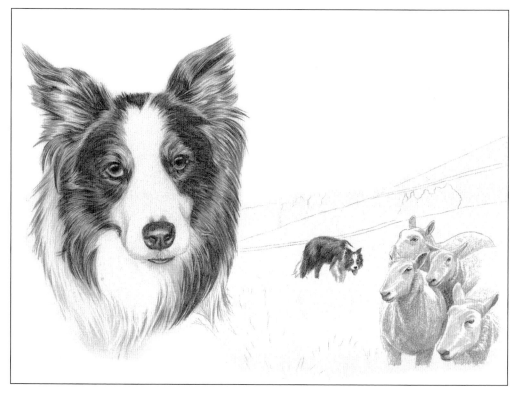

Step 10 I finish the sheep by giving their white heads form through delicate shading. I use an H pencil to apply light, controlled strokes, and I use tack adhesive to pull out graphite from the highlighted areas of the head. At this point, I have developed three areas of interest within the drawing, creating a triangular composition. Now I stand back and assess the balance of tonal value of each area, making sure none is too faint or too overwhelming relative to the others.

Lightening for Distance

In addition to appearing proportionately smaller than objects closer to the viewer, an object in the distance also should appear lighter in value. Use tack adhesive to lighten the subject's overall tone. Simply form the tack adhesive into a ball and roll it evenly over the entire figure.

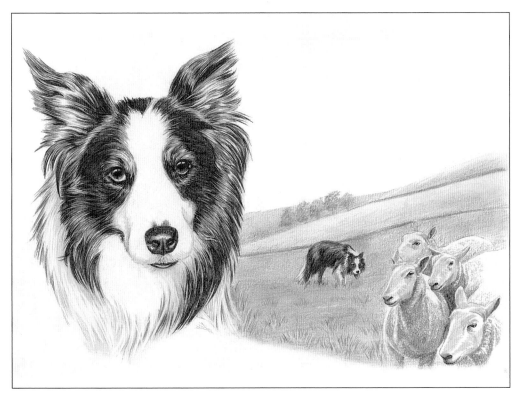

Step 11 At this point, I unify the elements of the drawing by filling in the countryside with a light tone. I use an HB to apply a layer of tone over the hill, gradually decreasing the pressure to create a lighter tone as I move into the distance. I add a short wall through the middle ground and a faint row of trees in the background to break up the large block of shading. Finally, still using an HB pencil, I add some short strokes in the foreground to suggest blades of grass.

Drawing Wool

Rendering a sheep's coat is much different than rendering a dog's coat. The short hair of the sheep's face is white with a smooth texture, and the body is covered in thick, short curls. Because the coat is the same length all over the body, there is no distinct pattern of growth. All the curves and creases are soft, and the coat gently follows the form of the body. As you apply the circular strokes, pay close attention to the highlights that suggest the form, avoiding any hard lines or harsh separations.

FOCUSING ON CONTRAST

When working with a light-colored dog, it's particularly important to diminish the level of detail in the background. Light-colored dogs don't have much contrast in their hair, so the background elements easily can attract the eye. Keep any intricate elements lighter in value and refrain from adding fine details, such as veins in leaves. This will keep the viewer's focus on the dog.

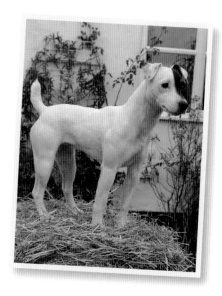

Emphasizing the Subject As is, the photograph has too much detail. I decide to take the background "out of focus" by blurring, lightening the overall values but maintaining enough contrast with the dog's coat. This emphasizes the sleek shape and muscular stature of this mostly white Parson Russell Terrier.

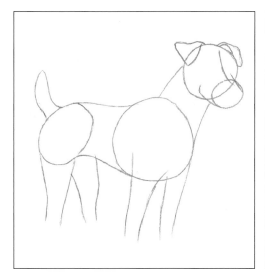

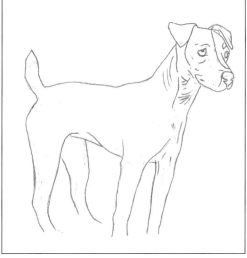

Step 1 Using an HB pencil, I sketch circles for the skull, chest, hips, and muzzle. Once I'm sure the relationships of these circles match the reference, I join the circles to create the outline of the dog's body. Then I indicate the position of the legs, tail, and ears. I also add a guideline up the center of the dog's face to help me position the features. At this early stage, the sketch is already recognizable as a Parson Russell Terrier!

Step 2 Next I focus on refining the outline, following the subtle curves that make up the shapes of the dog. Then I erase the circular guidelines that I no longer need. I indicate the shadowed area of the neck and head with a few short strokes, which will speed up the shading process later. I also block in the eyes, nose, and brows. I don't indicate the paws because they will be hidden in the hay.

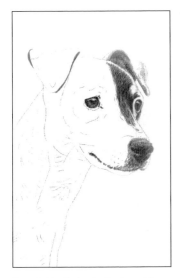

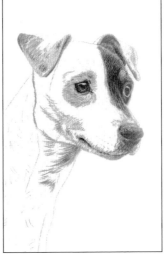

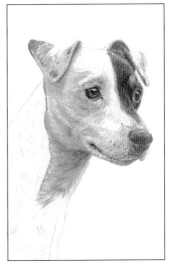

Step 3 I begin the shading by tackling the facial features. At this stage, I use a 5B pencil and only block in the darkest areas, including the eyes, the shadow on the nose, the mouth, and edges of the ears. The dog has a black patch around its left eye, which I darken as well.

Step 4 The head is relatively small, so attaining detail will be a challenge. With a sharp H pencil, I apply midtones to add hair around the eyes and on the mouth, cheekbone, jaw line, and ears, applying short lines that follow the direction of hair growth.

Step 5 I use an H pencil and short strokes to add the lightest areas of hair over the face, gradually fading out the strokes as I progress toward the top of the head. Then I add mid-value dots near the mouth to represent the areas from which the whiskers grow.

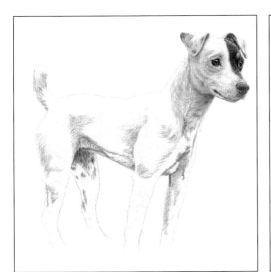

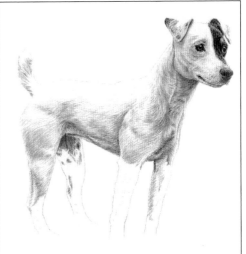

Step 6 Now I switch to an HB pencil and begin stroking in areas of hair on the torso, first addressing the darkest areas in shadow, such as along the insides of the far legs. Every stroke I make on the body is short and follows the direction of the hair growth, accurately communicating the feel of this dog's short, smooth coat.

Step 7 Still using the HB, I continue stroking in hair across the entire torso, layering my strokes smoothly and evenly. I develop the shadows of the dog's form that indicate the muscles beneath, such as on the hind and front legs.

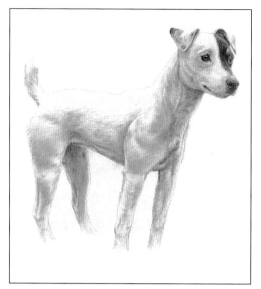

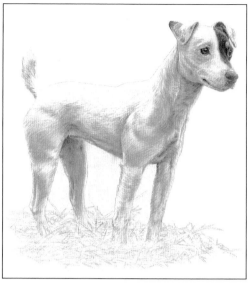

Step 8 I take a second sweep across the body using a 2H pencil, adding the subtle middle and light tones, and reducing the pressure on the pencil for the lightest areas. The muscle definition of the Parson Russell Terrier is an important characteristic of the breed, so I pay great attention to where the muscles sit, particularly around the shoulder and hind legs. I emphasize them by shading the undersides of the muscles.

Step 9 At this point, I add tone to the hay with an HB pencil. This is the only area that directly touches the dog, so I need to get its tone and value to sit well with those of the dog. I use negative drawing to begin, just as I do for intricate hair. Because hay doesn't follow any particular pattern or direction, I sketch it in using random pairs of parallel lines that cross each other.

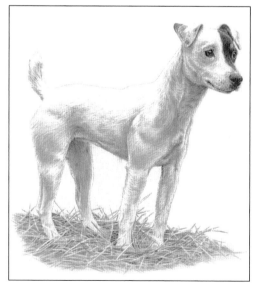

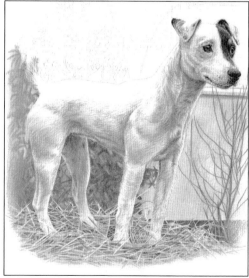

Step 10 With a 2B pencil, I fill in the negative areas of the hay with the tone of its darkest shadows. You can see that this simple approach immediately produces the impression of hay. As I continue to add the shadows, I gradually fade out the edge of the hay along the bottom and sides. If any part of the edge is too harsh, I roll tack adhesive over the area to lift out some graphite and lighten the overall tone.

Step 11 Switching to an HB pencil, I begin adding the wall and foliage in the background, pushing the dog forward and creating a sense of depth. I add tone to the wall on the right, giving the area interest by adding a cluster of twigs. Then I draw ivy growing up the left two-thirds of the wall. To avoid attracting too much attention to the background elements, I keep them indistinct by blurring them slightly with a blending stump.

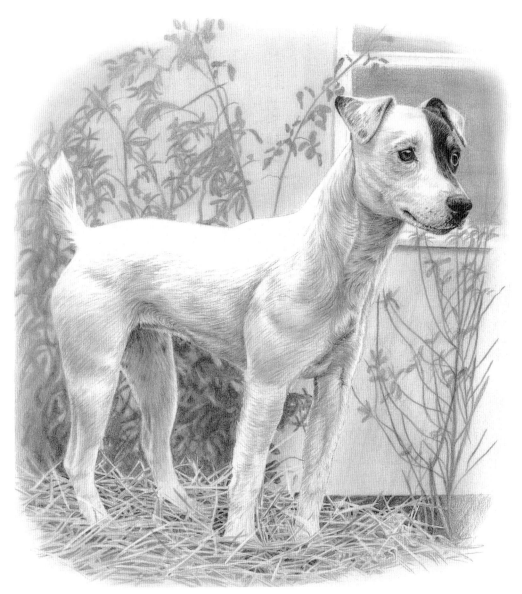

Step 12 I continue addressing the background of the drawing, working upward with an HB pencil as I finish the ivy, ending just above the dog to contrast with the light value of its back. I add a middle value to the window behind the head to contrast with both the light and dark hair. Then I stand back from the drawing and focus on areas where the dog blends into the background, darkening or lightening where needed. To finish, I sharpen details on the dog and blend any harsh lines of the background.

CONCENTRATING ON VALUES

When rendering a long, shiny coat of a middle value (such as that of this long-haired Dachshund), study the reference and note even the subtlest change in value—expressing these changes in your drawing will keep your subject from appearing flat and two-dimensional. Try squinting your eyes while viewing your reference, as this can help you see the highlights and shadows much easier.

Step 1 Using the light touch of an HB pencil, I begin with basic shapes, sketching rough circles for the head, chest, and hips, adjusting them as needed to achieve the correct proportions. I join the circles to create a rough outline of the dog. Then I position the nose on the left side of the dog's face for this three-quarter view of the head.

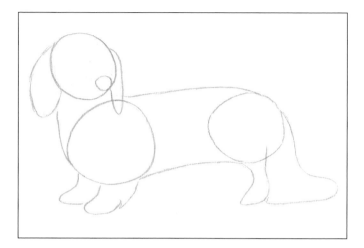

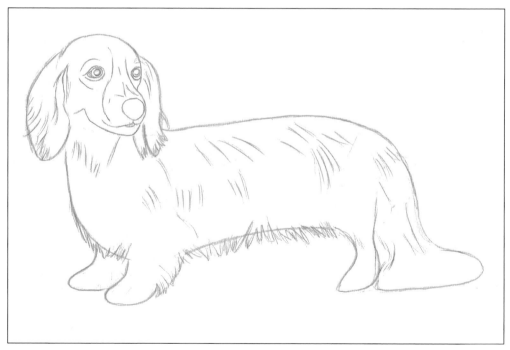

Step 2 I erase the circles that are no longer needed; then I draw the muzzle and block in the eyes and mouth. I indicate the planes of the muzzle with lines to guide future shading. Then I sketch in some guidelines to indicate the direction of hair growth on the torso, along the chest and belly, and on the ears.

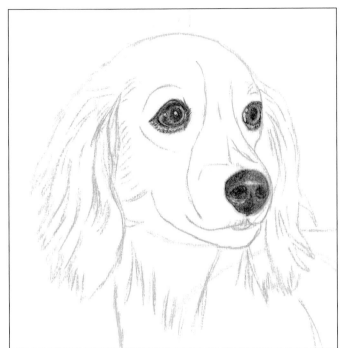

Step 3 With my general layout in place, I begin adding detail to the features using a 5B pencil. The eyes and nose are relatively simple with only subtle highlights. I darken the pupil and skin surrounding the eye, leaving a ring of midtone for the iris. I fill in the nose using circular strokes, applying a dark value to the nostrils and underside of the nose. I leave a soft, horizontal highlight across the top of the nose. Although the finished piece will retain a somewhat sketchy style, I add enough detail to the features to make the face the focal point of the piece.

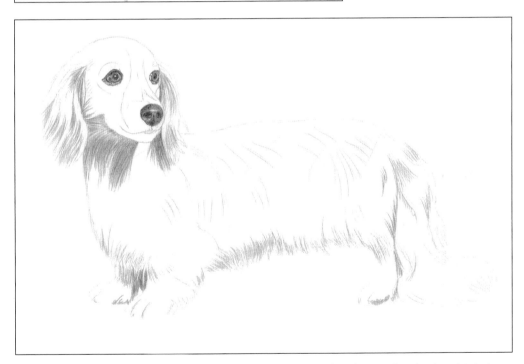

Step 4 Now I begin shading the hair using an HB pencil and strokes that taper at the ends. I start along the edges of the body and paws; then I target the darker areas on the neck, around the ears, and on the underside of the body and paws. I move freely and loosely as I draw lines in the direction of hair growth, using fairly long pencil strokes to imitate the breed's flowing hair.

Step 5 Now I move to the ear, using an HB to add long lines that follow the natural wave of the hair. I make sure that my strokes aren't too close together, keeping plenty of white paper showing through to suggest highlighted clumps of hair. Still using an HB pencil, I address the shorter hair on the rest of the face, paying close attention to the pattern of hair growth. Note the Dachshund's pattern of hair growth—it runs up away from the nose, around the eyes, and over the head. At this point, I keep the lightest areas of hair free of graphite.

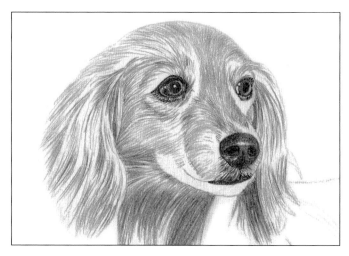

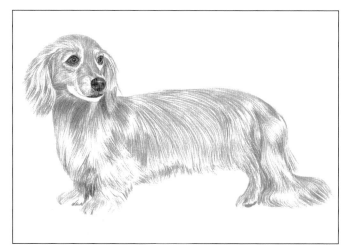

Step 6 I follow the exact same method and use the same pencil that I used on the ear in steps 4 and 5 to sketch the hair all over the body. The very nature of this less-detailed drawing style allows me to cover the whole drawing very quickly. As I approach the lighter areas, I reduce the number of strokes, keeping them farther apart, and lightening the pressure on the pencil. Again I leave the lightest areas of hair free of graphite.

Step 7 Now I have a basic map indicating the length and direction of hair for each section of the body. Following this map, I add midtones to the hair using an 2H pencil, following the same curvature of strokes to gradually build up the overall value.

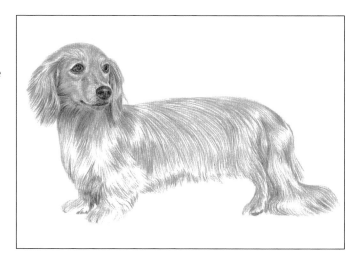

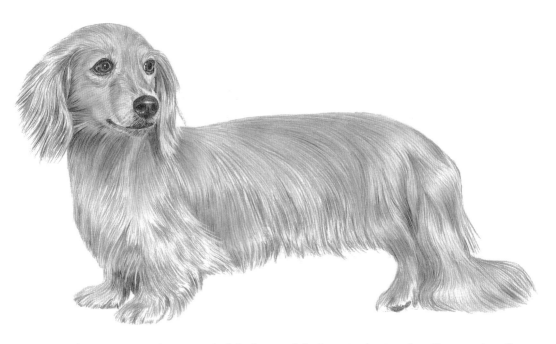

Step 8 To finish the piece, I lightly stroke over the "white" areas with the sharp point of an H pencil to add texture and to unify these sections with the rest of the coat. Finally, I blend all except the lightest areas with a tissue, eliminating the harsh lines I applied to define the hair. The blending also brings out more tonal value while adding a soft sheen to the coat.

Protecting the Paper

Every pencil artist has smudged a piece of artwork at some point, and often it's his or her own hand that is the culprit! I always place a piece of clean paper beneath my drawing hand to eliminate any contact with the drawing surface. And when working on a large drawing, I often use artist's tape to secure paper over areas where I'm not working.

CONVEYING EXPRESSION

From this priceless shot of a Basset Hound puppy, I want to create a portrait wherein the expression stands out more than anything else. To do this, I ensure that none of the background elements overwhelm the focal point—the dog's innocent expression. I keep the details of the grass to a minimum, instead merely suggesting the grass with lighter tones. This keeps the focus on those classic "puppy-dog" eyes!

"Grounding" a Subject with Shadow When rendering a full-body portrait from an unusual viewpoint, it's a good idea to "ground" the subject with a shadow. This prevents the dog from appearing to float above the drawing surface and also gives the viewer a better sense of the dog's form.

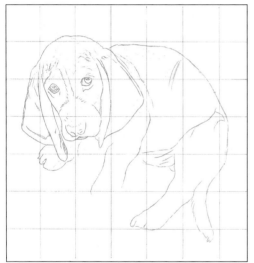

Step 1 I want to match the posture and expression of the pup as closely as possible, so I use the grid method to transfer the image to my drawing surface. I use an HB pencil to create a light grid made up of small boxes to ensure accuracy (see pages 16–17). I also block in lines for the highlights and shadows, which will help me shade in later steps.

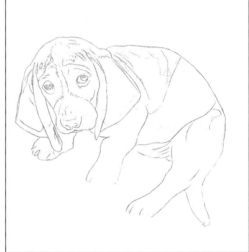

Step 2 Before erasing the guidelines, I make sure that I have copied over the exact shape of the puppy's eyes, as they are essential to communicating the dog's sweet, gentle expression. Then I erase the grid lines, being careful not to lose any of the dog's outline. I make sure no other adjustments are needed before progressing to the shading stage.

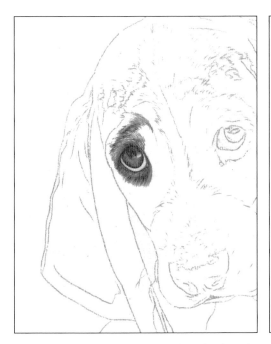

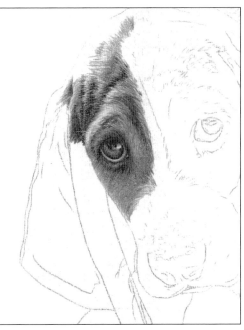

Step 3 Now I use a 2B pencil to block in the pup's right pupil, working around the highlight. I fill in the iris with a medium-dark value and create a darker outer ring, smoothing these tones with a blending stump. I darken the undereye area and begin developing the hair over the brow with short strokes.

Step 4 The skin of the brow is wrinkled. To express this, I create highlights along the tops of the folds by leaving the areas free of graphite. For the shadowed creases, I apply short strokes that are heavy and close to one another. As always, I make sure each stroke follows the direction of hair growth.

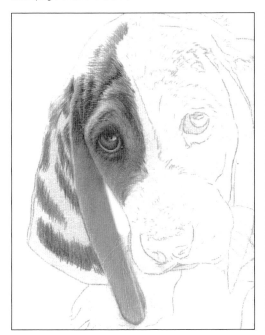

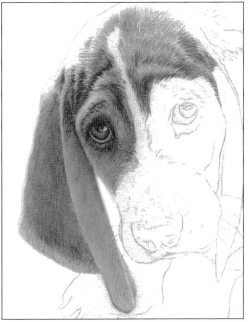

Step 5 Next I create the darkest areas on the ear using short, vertical hatching strokes. Then I apply a solid medium value of shading over the front flap of the ear, smoothing it with a tissue wrapped around my finger.

Step 6 I apply another layer of graphite over the ear (except the front flap) and blend with a tissue. I add hair over the left side of the puppy's head, stroking up and away from the eye and avoiding the white marking down the center of the head.

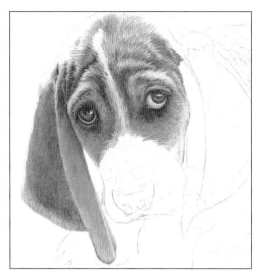

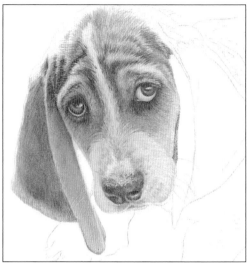

Step 7 Now I use a 2B pencil to shade around the pup's left eye. I place the iris and pupil high in the top outer corner of the eye, with more white showing in the inner corner. This emphasizes the submissive expression. To give the eye roundness, I lightly shade the inner corner of the eye, graduating to white around the outer edge of the iris. I draw the hair below the eye, gradually fading out as the hair becomes lighter.

Step 8 Still using a 2B pencil, I begin the nose by shading the darkest areas: the underside, the nostrils, and the side. I provide texture to the top using small dark circles, gradually increasing the gaps between the circles as I approach the highlight. I complete the nose by adding midtones over the circles around the front and a very light tone to the top. I finish the muzzle with very light H pencil strokes, and I indent the whiskers with a blunt tool.

Step 9 Now I use the same method that I used in step 6 to add tone to the puppy's left ear. When I shade over the whisker indentations, they become visible.

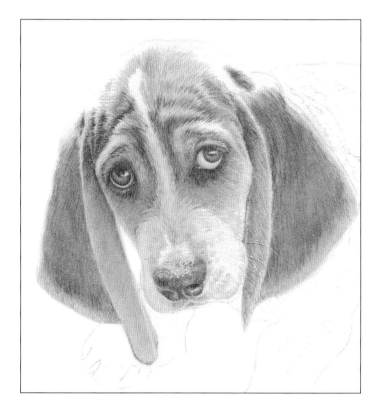

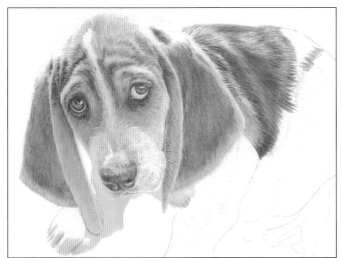

Step 10 With an HB pencil, I accentuate the fold of the pup's left ear by giving it a very light edge to contrast with the darker hair behind it. Then I add tone to the dog's right paw, shading in between the toes. Now I'm ready to begin the back and side of the body. I again draw a series of lines in the direction of hair growth, always drawing from dark to light. I create the ridges of hair near the middle of the body by alternating light and dark values in a bumpy, striped pattern.

Step 11 I use an HB pencil to block in the rest of the hair on the back, leaving the white stripe very lightly shaded and the top of the back and the top of the left hind leg unshaded.

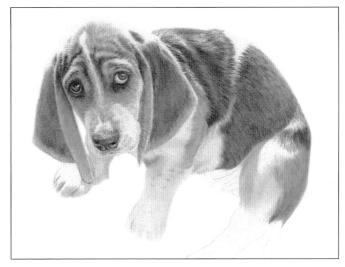

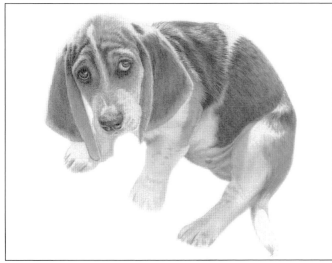

Step 12 With an H pencil, I add a shadow to the inner side of the hind leg and complete it and the left foreleg. I shade the stomach and blend with tissue paper to convey its nearly hairless surface. I leave the tip of the tail predominantly white.

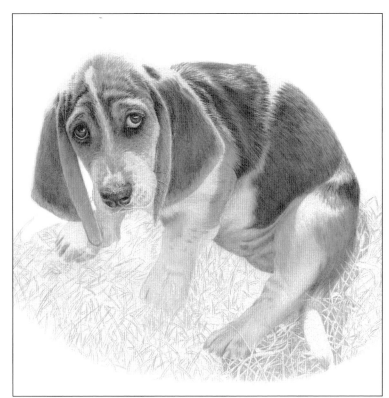

Step 13 With nothing underneath it, the pup appears to be floating in midair. To ground it, I add some grass and a cast shadow. I use an H pencil to draw each blade of grass as a pair of lines closing to a point. To contrast with the more uniform quality of the hair, I draw the blades in random directions. Then I shade around the tail, filling in the gaps between the blades of grass.

Step 14 Using the same method, I continue to surround the dog with grass. I want to keep the drawing from being too rigid, so I fade out the grass as I move away from the dog. The semicircular shape of the grass in the foreground keeps it from overpowering the drawing and serves to complement and emphasize the semicircular form described by the puppy's back.

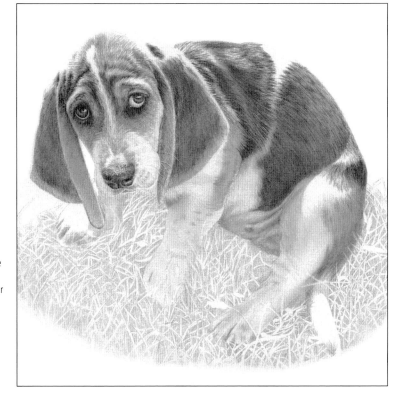

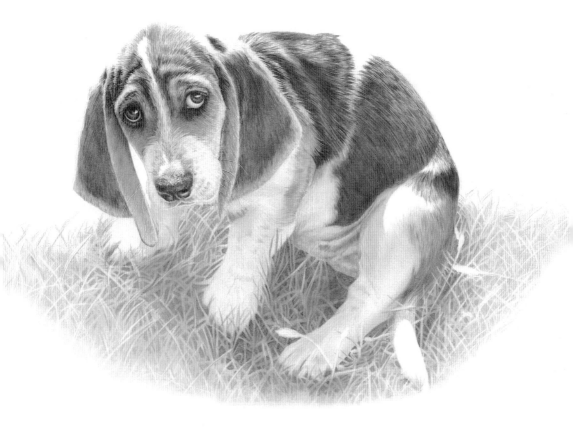

Step 15 To finish, I complete the grass (see "Creating Grass" below), creating shadows underneath the pup to ground it in the scene. Then I adjust the tone of the shadows to ensure that the Basset puppy still stands out as the focal point of the drawing.

Creating Grass

Rather than shading each individual blade of grass, I use a tissue to blend the graphite that is already there. I blend darker areas where there would be shadows, such as around the paws and under the pup's body. Then I use an eraser cut to a sharp angle to lighten some of the blades and bring them to the foreground.

LIMITING DETAIL

To quickly cover an area without having to render specific details—which is a great effect for this Bullmastiff's short, smooth coat—you can use a technique called "block shading." Simply use the underhand grip to fill in an area with solid tone, overlapping each stroke. Once you have done this, just smooth away any visible strokes with a blending stump and use tack adhesive to pull out highlights. For this Bullmastiff, the highlights will help define the short hair and visible muscles of this large and powerful breed!

Step 1 For this drawing, I start with three main three circles to represent the head, chest, and hips. I measure and adjust according to my reference; once I'm happy with the proportions, I use an HB pencil to build the outline around them. Then I sketch the muzzle and roughly position the eyes, nose, mouth, and ears.

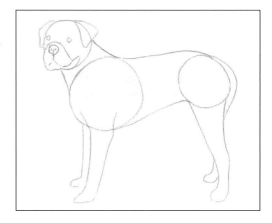

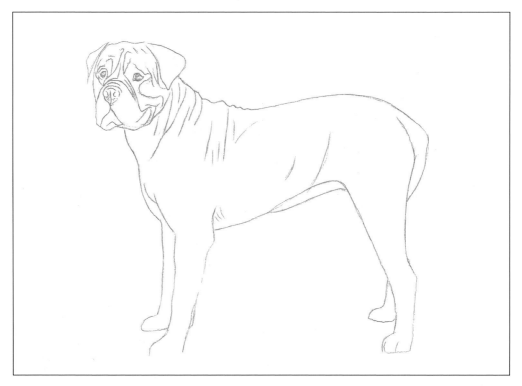

Step 2 I clean up the drawing by removing the circles and guidelines with tack adhesive. I refine the outline to better reflect the folds and curves that make up the dog's shape. I delineate the folds of skin across the face and over the dog's neck and back, providing a map for pulling out highlights and increasing shadows later.

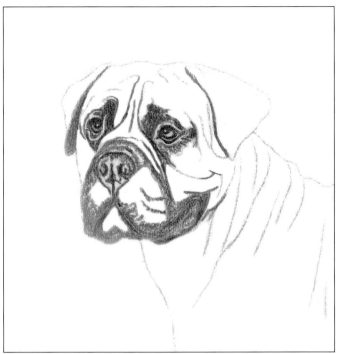

Step 3 The face of a Bullmastiff is generally very dark, so I begin shading by blocking in the darkest features with a 2B pencil, including the area around the eyes, on the muzzle, and along the ears. The muzzle will be almost completely black; however, I still want to show its form through subtle variations in value. I leave the lighter areas of the muzzle free of graphite at this point.

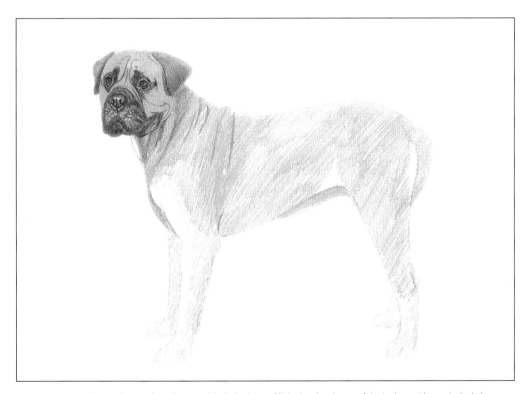

Step 4 Using an HB pencil with a flat edge, I use block shading to fill the head and most of the body, avoiding only the lightest areas, such as the chest and fronts of the legs. Then I add cast shadows under the ears, on the neck, and on the underside of the body. I don't bother shading in the direction of the hair growth, as I will eliminate the pencil strokes later when blending.

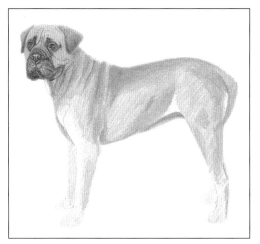

Step 5 At this stage, I concentrate on increasing the contrast between the dark and light areas. I apply a second layer of shading, using heavier pressure for areas of shadow and keeping my strokes very loose and sketchy.

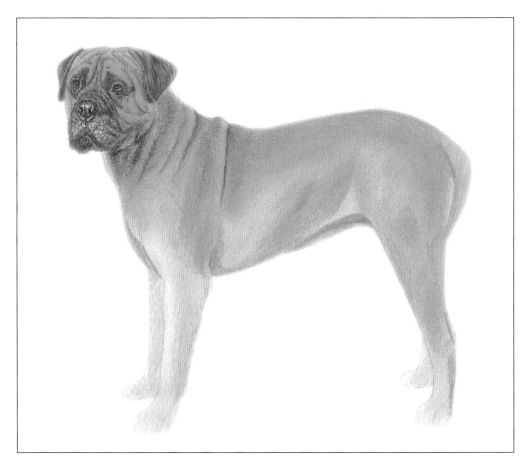

Step 6 Now I blend the graphite using a paper towel. I find that paper towels are great for creating a smooth, even finish when blending. I wrap the paper towel around my index finger to provide me with plenty of control; then I gently rub the towel over the drawing, avoiding the highlights on the muzzle, eyes, and body.

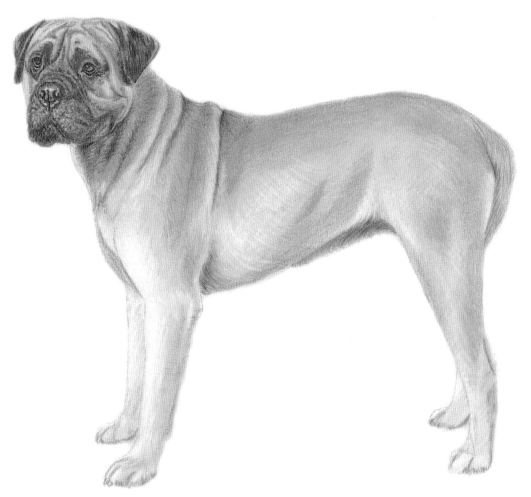

Step 7 Finally, to enhance the contrast, I lift out graphite to create the lightest areas of the dog. I use tack adhesive to dab along the right edge of each fold of skin on the face and back, as well as along the front of the legs and chest. Then I stroke a hard eraser in the direction of hair growth to remove visible lines on the forelegs, side of the chest, and top of the left hind leg. This simple method provides the illusion of detailed hair without distracting the viewer from the more important details of the face.

ISOLATING A FIGURE

Drawing a dog without a background accentuates the physical characteristics of a breed, as there is nothing to distract the eye from the proportions, stance, and features of the dog. It's best to begin these types of drawings with a strong reference photo that shows the dog in a balanced, attentive pose—a profile view is most effective, as it shows off the length and shape of the body. For this Australian Cattle Dog, I focus on the erect ears; alert eyes; broad chest; and strong, muscular neck.

Step 1 First I transfer the major outlines of the dog using the grid method. Then I sketch the features and lightly delineate the pattern of the coat by indicating the changes in value. Within each area, I use a few lines to suggest the direction of hair growth. Now I have a map that helps me visualize how to tackle the shading.

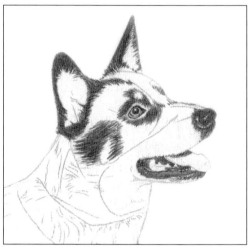

Step 2 As this drawing is of an entire dog, it won't require as much detail as a head-and-shoulders portrait. Using a 2B pencil, I shade the pupil and outer edge of the iris, the rim of the eye, the hair around the eyes, the nose (leaving highlights to indicate the bottoms of the nostrils), the outer edges of the ears, the black lips and gums of the mouth, and the hair on the cheek.

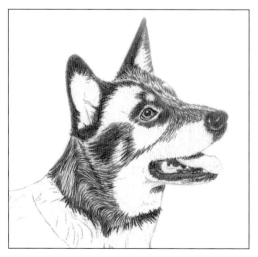

Step 3 Still using a 2B, I continue filling in the hair using strokes that follow the direction of hair growth, carefully following my reference. I use dark, thick strokes to add a base layer for the black areas of hair.

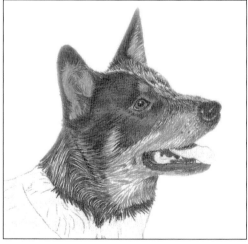

Step 4 Now I switch to an HB to add lighter, finer strokes inside the ears, on the muzzle, and on the neck. This unifies the coat and softens its texture.

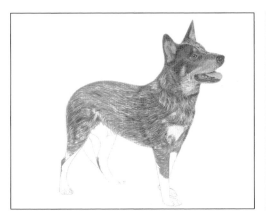

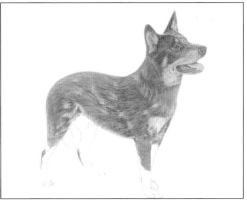

Step 5 As I move from the head to the body, I use the HB to draw directional lines over the torso and upper legs, placing the lines farther apart or closer together to make the areas lighter or darker. As with the head, I build up the dark hair first, leaving the lower legs and the chest light.

Step 6 Using the same technique as in step 5, I continue shading the body, building up the thick, mottled coat. I try to make the markings match my reference as closely as possible.

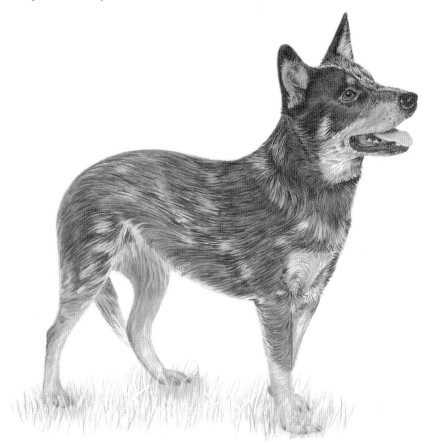

Step 7 With an H pencil, I add a layer of midtones over the body to provide the correct values in the coat and unify the patches, avoiding areas where the lines are farther apart. I complete the lighter hair on the feet and chest with fine strokes of a sharp H pencil; then I add the tail in between the hind legs. I finish by drawing random lines in various directions to suggest the grass that grounds the dog. My quick gesture drawing has evolved into a portrait that captures the cattle dog's eager, alert expression and stance.

USING THE SKETCH METHOD

A quick, sketchy style can be especially effective for drawing a dog with long, fluffy hair. (See page 8.) This style of drawing works particularly well for portraying a dog in motion or in the distance, when attention to detail is less important. Although you will be utilizing sketching techniques for this project, they will result in a semi-realistic drawing.

The Shetland Sheepdog (also called a "Sheltie"), with its long, full coat lends itself to a quick-sketching method. Remember to keep the head and features relatively detailed so they don't become overwhelmed by the size and texture of the rest of the body.

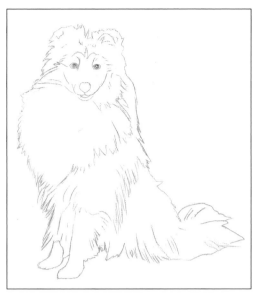

Step 1 I start by transferring the basic outline of the Sheltie from a reference photo using the grid method and an HB pencil. I delineate the main colors of hair, creating the large, white triangular section of the chest; this will make the shading stage simpler. I also block in the features and add a few lines to suggest the direction of hair growth.

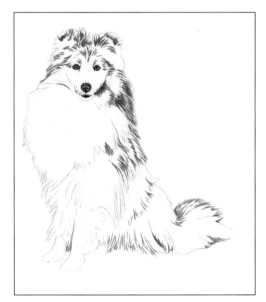

Step 2 Using a 2B pencil, I tackle the dark, detailed features, completing the eyes, nose, and mouth. Then I move on to the darkest shadows of the hair, using long strokes that taper at the ends to create the illusion of long hair. As I do this, I erase parts of the original outline that aren't covered by my new strokes.

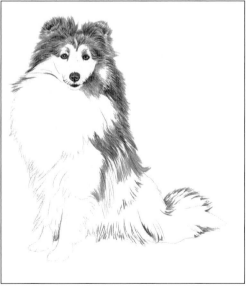

Step 3 I continue working in the hair, changing the amount of pressure on the 2B pencil so my lines aren't too uniform. Keeping the strokes loose, I carefully follow the direction of growth. I finish developing the darkest areas of the coat, moving over the top of the head and down the back.

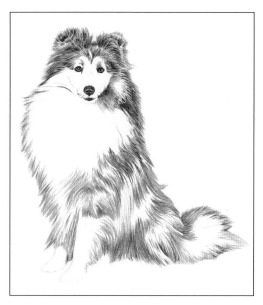

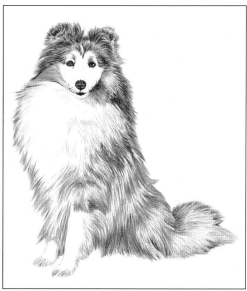

Step 4 Switching to an H pencil, I add a midtone value to the hair, working over the Sheltie's dark markings and into the surrounding areas. I also create the front of the dog's ruff using tapering strokes, erasing any of the initial outline that extends beyond my new strokes.

Step 5 I continue building up more midtones in the fluffy coat with the H pencil, working into the light chest area. I decrease the pressure on my pencil to create lighter midtones and place my strokes farther apart, still keeping them loose and tapered. I also add tone to the bottoms of the paws and across the dog's right cheek.

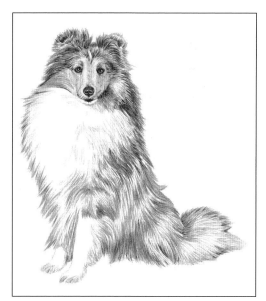

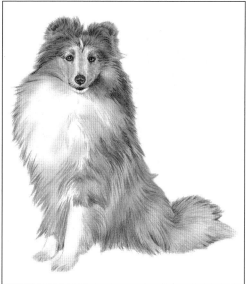

Step 6 Now I lightly shade the entire face with a 2B pencil. Following my reference closely, I apply short strokes in the pattern of hair growth, swooping under the eyes and moving across the cheeks. I leave two light strips along the sides of the muzzle to suggest its curved form.

Step 7 I blend the hair using a tissue wrapped around my finger. This unifies the hair with smooth tone while reducing the harshness of the pencil strokes. I leave the highlighted center of the chest white and refrain from blending the face, as this is the focal point and should remain crisp and detailed.

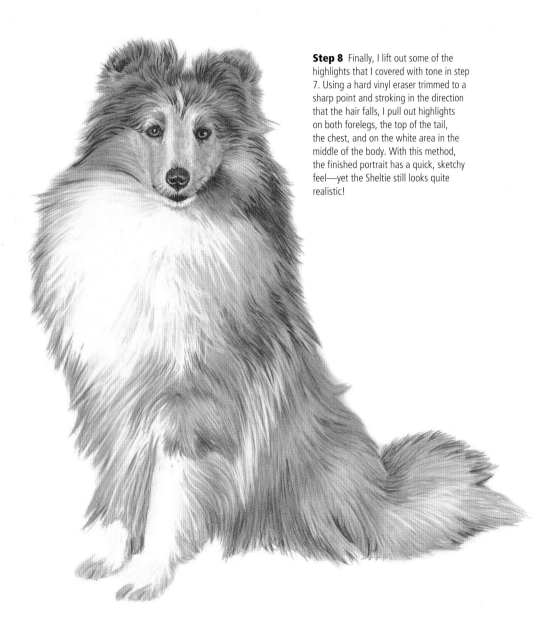

Step 8 Finally, I lift out some of the highlights that I covered with tone in step 7. Using a hard vinyl eraser trimmed to a sharp point and stroking in the direction that the hair falls, I pull out highlights on both forelegs, the top of the tail, the chest, and on the white area in the middle of the body. With this method, the finished portrait has a quick, sketchy feel—yet the Sheltie still looks quite realistic!

CLOSING WORDS

Dogs come in a range of shapes, sizes, colors, and personalities, offering a seemingly endless supply of inspiring subjects. Once you become comfortable with the techniques and drawing methods I have demonstrated in this book, I encourage you experiment with other references, materials, and approaches to find which ones suit your style best. It's a magical experience to sit in front of a blank piece of paper, pick up a pencil, and watch an image come to life and look up at you from the paper!